INFINITAS · GRACIAS

WE WOULD LIKE TO THANK:

Alfredo, Hugo, Luis, Daniel, and the entire Vilchis family •
Victoire and Hervé Di Rosa • Monica Cuevas • Monica Herrerias •
Martin Solares • Caroline Barcellini • Julien Sorez • E.G. •
Jean Jacques Beucler • Philippe Poupet • La Pop Galerie,
Pascal Saumade • Les Éditions du Seuil • Sainte Véronique

Originally published in France by Éditions
du Seuil in 2003 under the title *Rue des
miracles: ex-votos mexicains contemporains.*

Library of Congress Cataloging-in-
Publication Data:
Roque, Alfredo Vilchis.
[Ex-votos mexicains contemporains.
English.] Infinitas gracias : contemporary
Mexican votive paintings / Alfredo Vilchis
Roque, Pierre Schwartz ; preface by Victoire
and Hervé Di Rosa. p. cm.
ISBN 2-02-061861-3
1. Votive offerings—Mexico. 2. Votive
offerings in art. 3. Painting, Mexican—
20th century. 4. Folk art—Mexico—History—
20th century. I. Schwartz, Pierre. II. Title.
ND1432.M45R6713 2004
755'.2'097209045—dc22
2003016172

English translation by Elizabeth Bell
Book design by Valérie Gautier
English text design by Vanessa Dina
Cover design by Flux

Manufactured in France.

Distributed in Canada by Raincoast Books
9050 Shaughnessy Street,
Vancouver, British Columbia V6P 6E5

10 9 8 7 6 5 4 3 2 1

Chronicle Books LLC
85 Second Street,
San Francisco, California 94105

www.chroniclebooks.com

ALFREDO VILCHIS ROQUE · PIERRE SCHWARTZ

foreword by VICTOIRE and HERVÉ DI ROSA

INFINITAS GRACIAS

CONTEMPORARY MEXICAN VOTIVE PAINTING

SEUIL CHRONICLE

CONTENTS

PREFACE

I met Alfredo Vilchis Roque at La Lagunilla flea market in Tepito, Mexico, which he calls the biggest museum in the world, because "you find everything there—a key, a marble, a work of art, a broom, a photograph—and you meet every social class: common people, artists, intellectuals, politicians . . ." Leonardo da Vilchis de la Lagunilla, as he has been nicknamed in his circle, can usually be found there on Sundays, surrounded by his sons, Hugo, Daniel, and Luis, exhibiting his votive paintings, taking orders for them, making contacts. Later on, I visited him in his neighborhood, Minas de Cristo (Mines of Christ), in the southern part of the city.

In Mexico, going anywhere is often the beginning of an adventure, but driving to Vilchis's house is like embarking on a treasure hunt. You must tell the poor cab driver to look for, in turn, the high-tension power lines, the fire station, the Observatorio subway station, and Domino's Pizza.

With a little luck, these directions led us to the garnet-red house on Calle Zurutusa. Vilchis was waiting for me and without ado ushered me toward

the workshop that crowns the building. I passed through several rooms, one on top of the other, meeting the entire family along the way.

El Rincón de los Milagros, the Corner of Miracles, which overlooks the entire neighborhood, is at once an exhibit hall, a work space, a library, a cabinet of curiosities, a meeting place, an observation post, a confessional. Visible in the distance are gigantic advertising images, outsize portraits of candidates in upcoming elections.

It is in this extraordinary spot that Vilchis stockpiles his documentation: press clippings, devotional objects, old photographs, assorted books. It is here that he receives collectors from all over the world and people from the neighborhood. It is here that he listens to the stories and confidences that generate his paintings.

As he showed me images, one after the other, Vilchis explained: This was Luis poisoning himself when he thought he had AIDS, this was Juan falling from a scaffold, that was María, "only" wounded by her alcoholic stepfather. It was a mix of the tragic and the ridiculous, of simplicity and respect.

Seen from this watchtower, the human condition appears immensely fragile. I had the impression of making contact with eternal truths and receiving a few life lessons at the same time.

That day, we brought up the idea of a book.

I returned a few months later. A book, a publisher, lots of pictures—it took him several days to believe me. "A miracle—it's a miracle," he said at last. Hanging from the ceiling, a newly completed Virgin of Guadalupe was almost dry.

—Pierre Schwartz

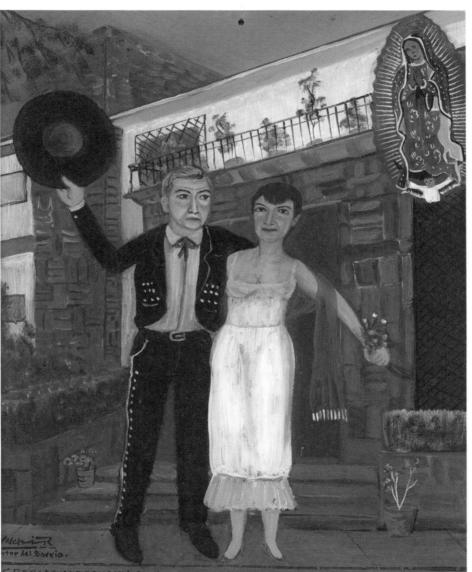

GRACIAS VIRGENCITA DE GUADALUPE QUE EN ESTA CASA ENCONTRAMOS LA FELICI...
Y EL AMOR QUE NOS UNIO EN ESTE MEXICO LINDO DEL CUAL NOS LLEVAMOS BONI...
RECUERDOS DE SU CULTURA Y TRADICIONES LAS LLEVAMOS EN NUESTROS CORAZ...
VICTOIRE Y HERVE DIROSA LOMAS DE CHAPULTEPEC MEXICO DF AGOSTO DEL 200...

Alfredo Vilchis Roque, Painter of Miracles

If you place an order with Alfredo Vilchis Roque, known as Leonardo da Vilchis to his friends, it's because you have a promise to keep, a tale to tell, a prayer to craft, a miracle to announce. Perhaps it is also to proclaim your admiration for the Virgin of Guadalupe, bartering in exchange for her services a small painting on metal relating your story. Nearly always, it is a tragic story that ends well: "There is no votive offering without a miracle behind it."

You found yourself on the brink of catastrophe because of a violent, jealous husband or due to drugs and alcohol. You had a brush with death after the collapse of a scaffold, or a train wreck, or your horse was bitten by a snake, or there was an earthquake. Perhaps all natural means had been exhausted by the time you resorted to the divinity, who granted the return of your health, or of love. Your plight was sheer anguish, making relief all the more sublime. Hence the fervency of your promise made in the moment to express gratitude to your benefactor with a votive painting.

Thus Vilchis is at once a painter of miracles, a self-taught intercessor, a public scribe of our misfortunes and our hopes, a chronicler of wonders, a commission worker in the field of faith, and a contemporary artist who makes use of the traditional, as certain African painters do. He will recount your small story with a happy ending, and in so doing recount the story of the neighborhood, the capital, Mexico, and the world at the onset of the twenty-first century.

The votive painting arrived in Mexico five hundred years ago, and it is in Mexico that it has manifested its greatest vitality and endurance. The retablo, or *milagro* (miracle), as it is also called, is not just another item in a secondhand store—it is truly a living custom. The Mediterranean region and Europe in general have had a history stretching back to antiquity of votive offerings in all shapes and sizes—from prosthetic limbs to rings and chains of precious metal to the *Victory of Samothrace* to entire cathedrals. In the Old World, there was no end to human gratitude to deities for their kindnesses.

Imported by the Spaniards to Mexico in its pictorial form, usually as an immense oil on canvas, the votive was adopted in the Americas by populations that already practiced offerings or sacrifices to ask a gift from Heaven or give thanks for favors received. Yet, of all the Spanish colonies in the Western hemisphere, it was in Mexico that the votive attained the greatest popularity, longevity, and level of artistic development.

In the form we know today, a small image on a sheet of metal, the votive painting dates to the nineteenth century. The thousands that have been preserved for two centuries in museums, churches, shrines, and private collections are invaluable records of Mexican history—both of major events and of daily life.

What do they show us? Mexican interiors: a room empty, but for a bed or the family altar. Mexican landscapes—immense expanses of sky and earth, snowy volcanoes, fields of maguey cactus or corn. Engineering features—roads, towns, and cities. People's professions. Work in the silver mines. Political unrest. Foreign invasions, or "interventions," as they're called in Mexico. Natural elements in all their violence. And a veritable Mount Olympus of devotional figures: Christ, Our Lady of San Juan de los Lagos, the Holy Infant of Atocha, Our Lady of the Talpa Rosary, the Virgin of Solitude, the Virgin of Zapopán, San Nicolás, San Judás Tadeo, and Jesus of the Column, among others. In the twentieth century, a few mortals have even been elevated to the ranks of near saints. Victims of injustice who met a violent death, they intercede, years later, in favor of the most humble, those without rights: Juan Soldado (the Soldier), Pedro Blanco, the Child Fidencio, or Jesús Malverde, the patron saint of drug dealers in Culiacán.

These little scenes describe an extremely close and familar relationship between worshiper and divinity—who is called variously *virgencita, madre, madrecita, Sanjuanita*. It is a relationship always mistrusted by the clergy and the Church, which are invariably absent in votive paintings, excluded—short-circuited, as it were—from this privileged dialogue. On the opposite side, the strict secularization imposed by the state in the twentieth century after the Mexican Revolution failed to make the slightest dent in people's devotion or the spread of popular votive paintings and images of the saints.

In the nineteenth century and the early part of the twentieth, those who commissioned such works usually sought protection from the ravages of sickness, epidemic, famine, war; indeed, the aggregate of thousands of such small, personal episodes yields a giant mosaic of the perils besetting life in those times. Before the Mexican Revolution, in a century of political unrest and military clashes, this magical art of the people flourished in the heart of Mexico—the provinces of Jalisco, Guanajuato, and San Luis Potosí—inspired by local images that attracted substantial pilgrimages.

What has changed in the profession of *retablero* (maker of retablos) as we embark on the twenty-first century? Very little, really. Mainly, anguish and fear have relocated—from the space of the countryside to that of the city, where the hopes and frustrations of migrants from all over the country are concentrated.

Certain subjects recur throughout the centuries: natural disasters, roadway accidents, domestic violence, street brawls, jail, household mishaps. Only now, the sicknesses have different names, there is more surgery, and violence has moved from the highway to the streets of the Mexican megalopolis. The theme of immigration to the United States spans the whole of the twentieth century: From the railroad workers of the late nineteenth century to present-day farmworkers, Mexican labor has made a huge contribution to the economy of the American West. Jorge Durand and Douglas S. Massey produced a study of retablos among Mexican migrants to the United States, *Miracles on the Border,* published by the University of Arizona Press in 1995.

More than half of Vilchis's votive paintings are dedicated to the Virgin of Guadalupe, the patron saint of Mexico. Appearing on four occasions to the shepherd Juan Diego on Tepeyac hill in 1531, the Virgin ordered that a church be constructed to her glory on this spot, where a temple to the Aztec goddess Tonantzin had once stood.

During this century, the only testaments to her apparitions and the miracles worked by her image were the oral tradition and the thousands of votives hanging in her shrine. In 1544, however, Franciscan friars commissioned an oil painting more than six and a half by sixteen and a half feet in size entitled *Franciscan Procession from Tlatelolco to Tepeyac, Praying for the Intercession of the Virgin of Guadalupe to End the Plague (Cocolixtli) of 1544.*

This work demonstrates the scale of her worship among the people and, as well, the strength of the vehicle of the votive painting in expressing their devotion.

The Virgin of Guadalupe became the official patron saint of Mexico in the eighteenth century. She later served as the emblem of national identity linked with Independence in 1821, and after that as Queen of the Americas. Even in our times, her worship is extremely widespread, and, thanks to her, Mexico City has become a sacred city, visited as such by American Catholics: *Non fecit tal iter amni nationi* ("She did not reserve the same fate for all nations!"). She coexists, however, with local images that are highly charismatic, if lacking her well-orchestrated media profile, such as the Virgin of San Juan de los Lagos.

Today, under the paintbrush of Alfredo Vilchis, *pintor del barrio* (neighborhood painter), the Virgin of Guadalupe intervenes to heal the wounds of bullfighters, boxers, and wrestlers, aid prostitutes attacked on the job, save street children from the dangers of drugs, even spare spray-can graffitists nabbed by the police. With her benevolent attention, she watches over a mariachi who falls ill, a child who swallows a marble, a 90-year-old Mexican grandmother who wishes to see Pope John Paul II again before she dies, a fire eater who has burned his mouth. There is no such thing as a small miracle!

The gesture, the offering, is laden with meaning. Alfredo Vilchis is well aware that his profession is an uncommon one, and he transmits this consciousness to his sons. "I am constantly telling them," he says, "'To be a *retablero* is not just any job. It is very beautiful work, but very painful. It must be done with respect—not only for money. We are the messengers of people's feelings.'"

The symbolic offering of the votive establishes a triangular relationship among the person making the offering, the artist, and the divinity. Vilchis, the *milagrero* (painter of *milagros,* or retablos), becomes the intermediary between devotee and deity, setting up the terms of exchange and reciprocity. It's tit for tat—a miracle for a work of art, a painting to say "thank you," as promised.

In his paintings, Vilchis captures the moment when the divine intervenes tangibly in earthly affairs, the instant in which Heaven and Earth are

unified, in which the marvelous intrudes upon the everyday. An intimacy is established between the divinity and the recipient of the miracle: A human in distress calls out, and the holy figure considers the matter, opens his or her arms, and descends from the clouds to perform the miracle. Sometimes, very rarely, the text mentions the artist to thank him "for painting this the way it was told to him."

Over the centuries, the votive has created a specific language, which has crystallized into a dual narrative, written and figurative. The text, usually at the bottom of the painting, appears in a phonetic, approximate spelling but with very tidy calligraphy. It nearly always indicates the date, place, and circumstances of the miraculous event, and the favor granted, but almost never mentions the painter's name. Above is the representation of the news item, as though on a little color screen, with its backdrop of earth and sky. At the top appears the image of the divinity (sometimes, two, three, or four of them), close to the world of mortals but often separated by a cloud or a ray of light. During the twentieth century, the successive influences of photography, movies, and comic strips on the mise-en-scène and composition of the images can be observed. We see evidence of the transportation revolution, urban growth, the rise of modernity, and the evolution of artistic techniques: Sometimes, a photograph of the person commissioning the work, photocopies of documents, or even a saint's preprinted image bought in a store are pasted onto the painting. Today, retablos are most often painted in oil on pieces of scrap metal, executed in a style at once classical and naive.

Most *retableros* are anonymous artists, but some, like Hermenegildo Bustos (1832–1907), are famous. A few have even founded dynasties, such as the Rivera family of Guanajuato and the Almanzas of San Miguel de Allende.

As for Vilchis, he was born in the José María Pino Suárez district of Mexico City. His father was a farmhand from Mexico state who had been transformed into a factory worker by the city. After primary school, Vilchis worked as a newspaper vendor, a day worker, and a mason's helper and at the many sorts of other subsistence jobs held by most inhabitants of the Distrito Federal, or D.F., as the capital is known. Twenty years ago, he found himself jobless and began to paint miniatures and sell them to neighbors or tourists. One day he came across a votive painting, and the sight of it reawakened a

childhood memory that had left an indelible imprint: visits with his mother to the shrine of Guadalupe and the mesmerizing sight of hundreds of incredible images. It was this sudden illumination that led him to dedicate to the Virgin of Guadalupe his first retablo, made for a family that had escaped death in a traffic accident in Mexico.

Vilchis considers himself self-taught, tutored at "the school of life." He does admit to being strongly influenced by Frida Kahlo, having often visited her blue house in Coyoacán. He has studied Kahlo's work as well as that of Diego Rivera, and has even made copies of their works for sale.

Today he lives in Minas de Cristo in the western part of the D.F., an extension of his childhood neighborhood. It is a working-class quarter, close to gigantic traffic arteries and interchanges, made up of an accumulation of little cubical cinder-block houses. At the corner of the pedestrian street where he lives, there is a small neighborhood altar: the Virgin of Guadalupe in a glass box, decorated with garlands and impromptu votives. His workshop is on the top floor of a small building with little adjoining courtyards and irregular stairways. On the walls of his house are hundreds of votives from all eras, his personal collection. He looks out over the neighborhood in all his benevolence and talent, and the neighbors are no longer surprised to see journalists, diplomats, and celebrities coming and going at his house, or luxury cars idling at the curb, to the delight of neighborhood children.

He is also an active member of his community: He has organized numerous workshops and painted murals in the streets with children, mainly to keep them occupied, protect them, prevent them from falling hopelessly into drugs, petty thievery, or prostitution. He has created vocations. Today, young people come to consult him in his eagle's nest, and they take his opinion seriously.

Those who commission his works are either people from the barrio or artists, intellectuals, and collectors from all over the world. Sadly, those clients from the barrio have more and more troubles linked with urban living—violence, drug addiction, armed robbery, poverty. Others have problems with homosexuality, family, sex, or professional life. Still others commission works with artistic, topical, or historical themes or as souvenirs of their time in Mexico.

Vilchis's sons, Hugo Alfredo, Daniel Alonso, and Luis Angel, also paint votives, so that the family has inadvertently fallen into the tradition many other *retableros* have established.

The artistic quality of these works is incontestable, yet their recognition as art objects is recent and precarious. It has come about due to interest on the part of other contemporary artists and to the evolution, albeit sluggish, of attitudes toward popular art.

The interest demonstrated by numerous contemporary Mexican artists has promoted this art form. So many influences have contributed to its revalorization: the vision of nineteenth-century illustrator and artist José Guadalupe Posada; the personal collection of Diego Rivera and Frida Kahlo, along with the evident influence on Kahlo's work; the labors of "Dr. Atl," aka Gerardo Murillo (*Las artes populares en México*, 1921), and Roberto Montenegro (*Retablos de México*, 1950); and the attraction of David Alfaro Siqueiros. Extensive exhibitions throughout the twentieth century have also served as occasions to extract votive paintings from their domestic and religious settings and encourage public awareness of these popular treasures: from the Popular Art Exhibition of 1921, organized by Roberto Montenegro and Jorge Enciso under the presidency of Alvaro Obregón, to the 1996 exhibit at the Museo de Arte Contemporáneo de México, *Dones y Promesas: 500 Años de Arte Ofrenda (Bestowals and Promises: 500 Years of the Art of the Offering)*, by way of the exhibit *Mexico: Splendors of Thirty Centuries* at New York's Metropolitan Museum in 1990. The influence of votive painting continues today: One finds it in the work of artists such as Julio Galán or Francisco Larios, the latter producing decidedly humorous votives in 3-D computer graphics. For myself, during my stay in Mexico and in the series of works we created there, the votive painting was one of my predominant influences, both in composition and in pictorial manner.

Nonetheless, despite admiration from the masters and political efforts to revalorize popular art, votive painting has been treated with a certain condescension, viewed as anecdotal, a product of folklore, to be distinguished from "high art." But popular art must cease to be seen as a secondary art that has failed to undergo the "evolution" of "high art," and must be viewed as an independent mode of artistic expression, a phenomenon that follows its own

rules, a nonacademic human language. It is only then that votive painting will finally be admired as a full-fledged art form.

Rejected by a secular state that frowns on this demonstration of popular devotion, by a Church that mistrusts it, by an art world that does not acknowledge it as contemporary creation, the votive is welcome nowhere. And yet it continues to express with utmost precision and simplicity, directly and without affectation, a personal, magical message often conveyed with considerable talent.

This, indeed, is our intent regarding humble art: to offer a different view of marginalized contemporary creations. Today's votive paintings, marginal to both sacred and contemporary art, belong to humble art. With their heightened sense of communication and their disdain for style, artistic movements, or novelty at any cost, they exist outside official channels of art distribution and cultivate their own constantly renewed creative invention. Above all, they possess that indefinable grace, like the vision of a child before the magic of life.

—Victoire and Hervé Di Rosa

We wish to thank the artists and researchers in France, Mexico, and the United States who have taught us everything—or almost everything—about votive painting.

Bélard, Marianne, and Philippe Verrier. *Los exvotos del Occidente de México*. Mexico City: CEMCA, 1996.

Dones y Promesas: Quinientos Años de Arte Ofrenda (Exvotos mexicanos). Centro Cultural Arte Contemporáneo, Mexico City: Fundación Televisa, 1996. Exhibition catalog.

Durand, Jorge, and Douglas S. Massey. *Miracles on the Border: Retablos of Mexican Migrants to the United States*. Tucson: University of Arizona Press, 1995.

Montenegro, Roberto. *Retablos de México*. Mexico City: Ediciones Mexicanas S.A., 1950.

Murillo, Gerardo (Dr. Atl). *Las Artes Populares en México,* 2 vols. Mexico City: Ed. Cultura, 1921.

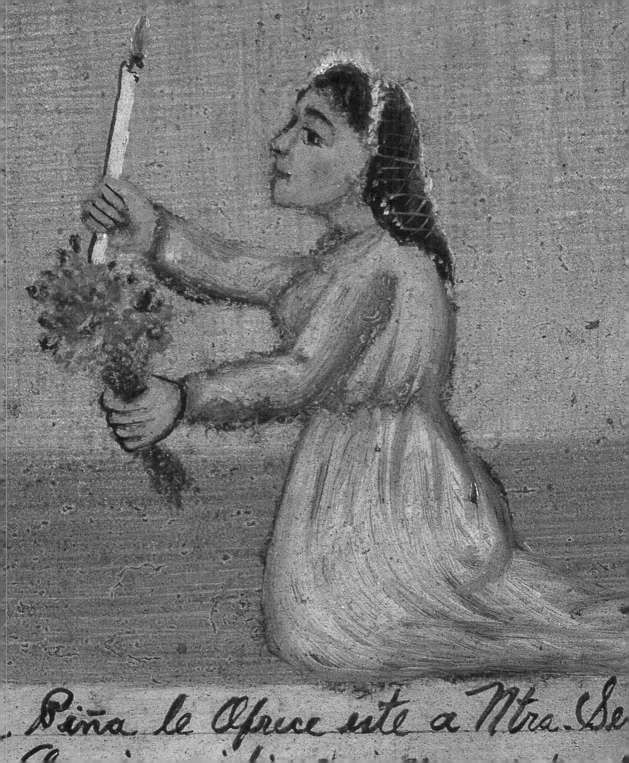

Piña le Ofrece este a Ntra. Se

SELF-PORTRAITS

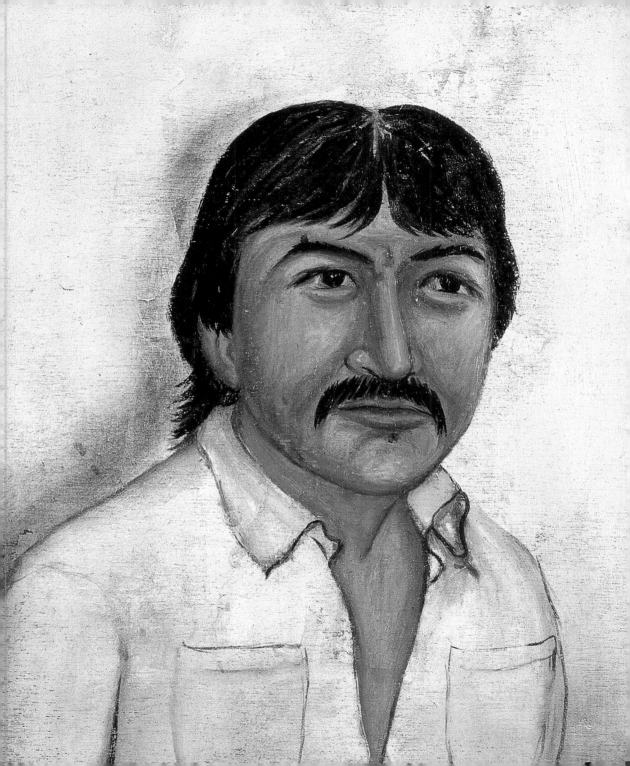

I dedicate this retablo in gratitude to my mother for giving me life, always blessing my path with the fullness of Faith, Hope, and Charity. From her place in Heaven, may she not forget me in my Mission, because Art is a Miracle. To my Wife for her Love and Support Always and to my Children for their Friendship, Affection, and Honesty. To Society for Accepting my Work and Allowing me to relate Facts, Events, Dreams, and Imaginings in my Beautiful Mexico. From Mexico to the World. Neighborhood painter. 20th century.

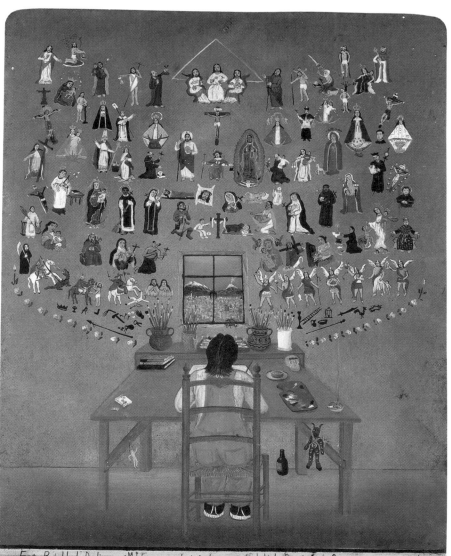

Este Retablo lo Dedico a mi Madre en agradecimiento que me dio la Vida Bendiciendo Siempre mi camino colmado
de Fé Esperanza y Caridad que alla en el cielo donde ella esta No me Olvide en esta Micion porque
el Arte es un Milagro a mi Mujer por su Amor y Apoyo Siempre y a mis Hijos por su Amistad Cariño y Onestidad
a la Sociedad por Acectar mi Trabajo por Permitirme contar Echos, Susesos, Iluciones é Imaginaciones en mi México Lindo
de México para el Mundo Da Vd. Retablero del Barrio 0/610 XX D de C.

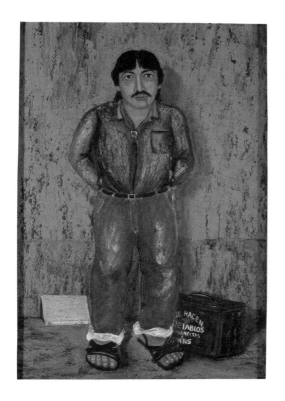

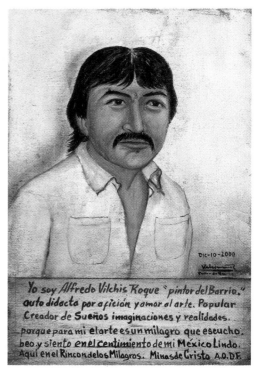

Yo soy *Alfredo Vilchis Roque* "pintor del Barrio."
auto didacta por afición y amor al arte. Popular
Creador de **Sueños** imaginaciones y realidades.
porque para mi el arte es un milagro que escucho.
beo y siento en el centimiento de mi México Lindo.
Aqui en el Rincon de los Milagros. Minas de Cristo A.O.D.F

This is Alfredo Vilchis Roque, your "neighborhood painter." Self-taught by affinity and love of art. Creator of dreams, imaginings, and realities for the people. Because for me, art is a miracle that I hear, see, and feel in the emotions of my beautiful Mexico. Here in Rincón de los Milagros.* Minas de Cristo, D.F.

*Corner of Miracles, the name of Vilchis's studio. Milagro is also another word for retablo.

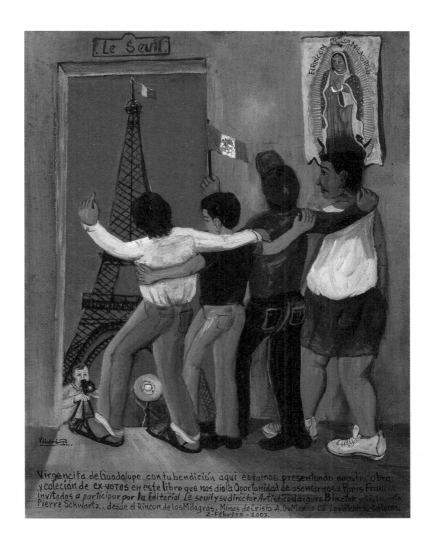

Sweet Virgin of Guadalupe, with your blessing here we are presenting our work and collection of votive paintings in this book, which gave us the opportunity to go to Paris, France, at the invitation of Le Seuil publishing house and its artistic director, Jacques Binsztok, and the photographer Pierre Schwartz. From Rincón de los Milagros, Minas de Cristo. Mexico D.F. The Vilchis retablo painters. February 2, 2003.

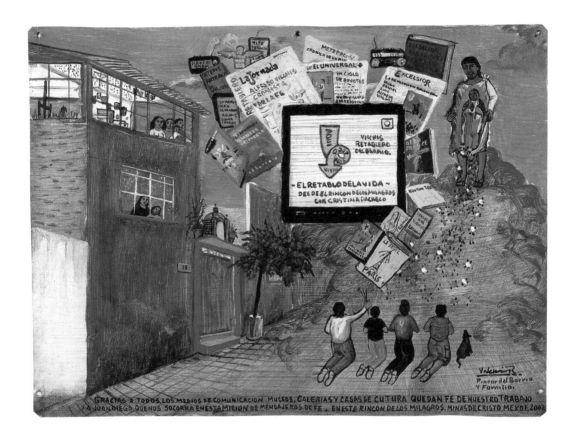

Thanks to all the communications media, museums, galleries, and cultural centers that bear witness to our work, and to Juan Diego, who has aided us in our mission as messengers of faith. In Rincón de los Milagros, Minas de Cristo, Mexico D.F. 2002.

[Headline on *La Jornada*, a left-wing daily newspaper:] "Retablo Maker Alfredo Vilchis, Chronicler of Faith"

[On the screen:] "Vilchis, Neighborhood Retablo Maker. The Retablo of Life, from Rincón de los Milagros, with Cristina Pacheco" (a well-known literary interviewer and writer)

[Headline on *El Universal*:] "A Century of Votive Paintings"

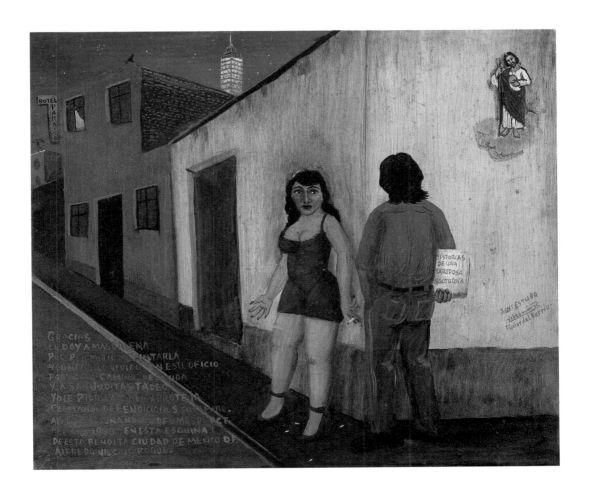

I give thanks to Magdalena for letting me paint her and tell about life in this profession on this path of life, and I pray San Judás Tadeo to guard and protect her and shower her path with the greatest blessings. This took place one night in the month of October in the year 1990 on this street corner of the blessed city of Mexico D.F. Alfredo Vilchis Roque.

PROSPERITY

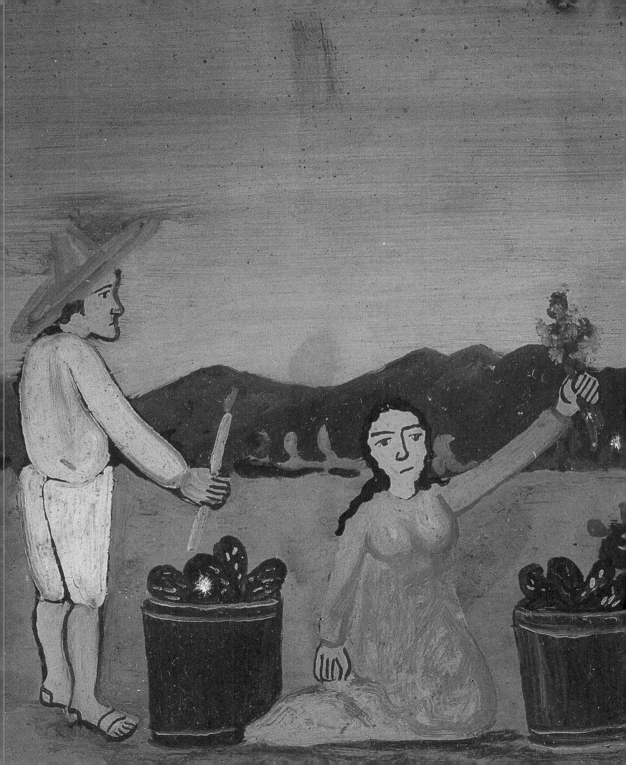

Agripino A——R——, an independent fisherman in Puerto Angel, Oaxaca, along with his son, makes known his thankfulness to the Most Holy María of Guadalupe, Queen of Fishermen, for granting that he be healed from the pain in his hands and giving him the strength to go on fishing for *guachinango** on the open sea, and put together enough to pay for my boat. Blessed be the catch, and may you give me aid. The month of March in the year 1950.

*Pacific snapper

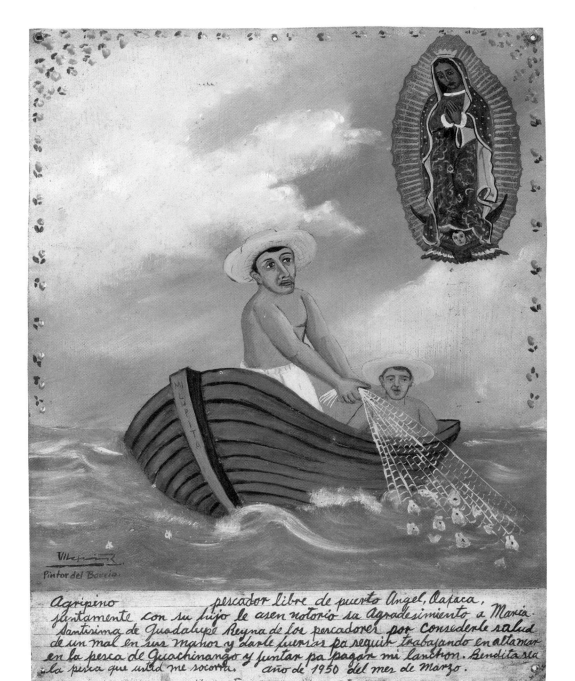

Vilchis
Pintor del Barrio.

Agripino pescador libre de puerto Angel, Oaxaca.
juntamente con su hijo le asen notorio su Agradesimiento a Maria.
Santisima de Guadalupe Reyna de los pescadores por consederle salud
de un mal en sus manos y darle fuersas pa seguir trabajando en altamar
en la pesca de Guachinango y juntar pa pagar mi lanchon. Bendita sea
la pesca que usted me socorra. año de 1950 del mes de Marzo.

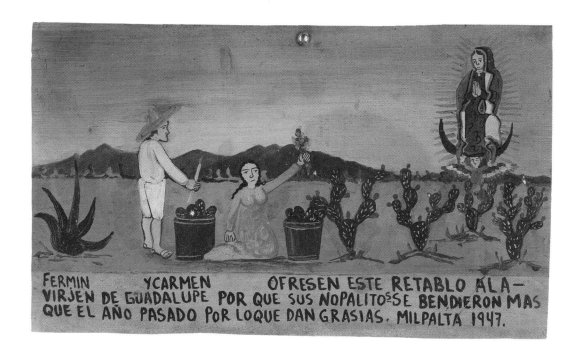

Fermín R—— and Carmen L—— offer this retablo to the Virgin of Guadalupe because their nopales sold better than last year, for which we are most grateful. Milpalta. 1947.

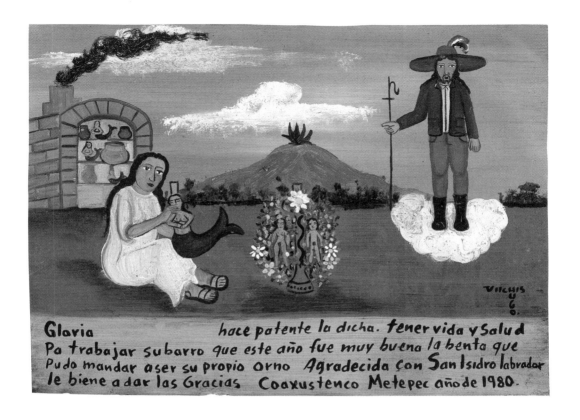

Gloria hace patente la dicha. tener vida y Salud
Pa trabajar su barro que este año fue muy buena la benta que
Pudo mandar aser su propio Orno Agradecida con San Isidro labrador
le biene a dar las Gracias Coaxustenco Metepec año de 1980.

Gloria L—— V—— bears witness to her joy at being alive and healthy to make her pottery, which sold so well this year that she was able to have her own oven made. In gratitude to San Isidro the Plowman, I come to give thanks. Coaxustenco Metepec. Year of 1980.

I give thanks to Jesus of the Salamanca Hospital that Don Melquiades's rooster and turkey appeared again. He had accused me [of stealing them] and wanted to take me to the police if I did not find them. I prayed to you to make it known that I had never stolen them, and so it happened. They appeared in the rooster yard, for which I bring you this candle and make known my uprightness by means of this retablo, which includes my portrait, so all faithful Christians will believe the truth of the wondrous miracles of our exalted Lord. Macario E——R——. Salamanca, Guanajuato. September 15, 1929.

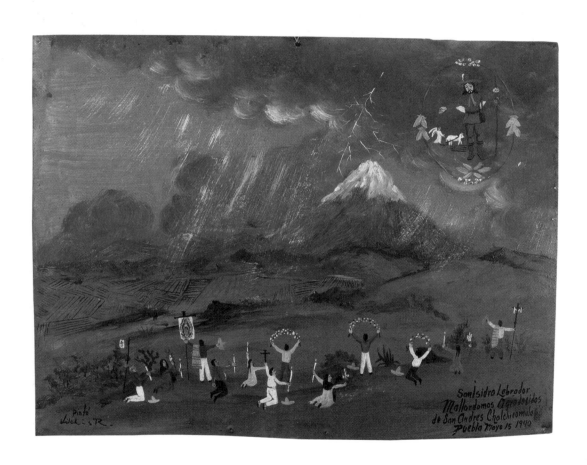

San Isidro the Plowman. His thankful celebrants from of San Andrés Chalchicomula, Puebla, 1990.

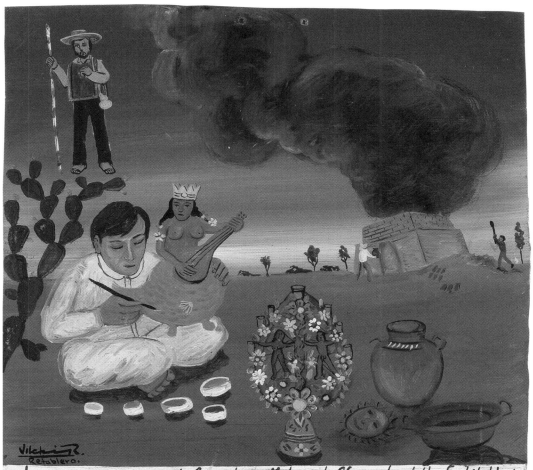

Vilchis R.
Retablero.

Juan de Coaxustenco Metepec. le Ofrese este retablo a SanIsidrolabrador
por consederle la dicha de Seguir trabajando su barro herencia de sus antepasados y Orgullo
de su pueblo en Compania de su familia que tanbien viven de este Oficio. 15 Mayo 2000.

Juan C—— R—— of Coaxustenco Metepec, offers this retablo to San Isidro the Plowman for granting him the good fortune to continue to work in clay, a legacy from his forebears and the pride of his village, along with his family, who also make their living from this profession. May 15, 2000.

RELATIONSHIPS

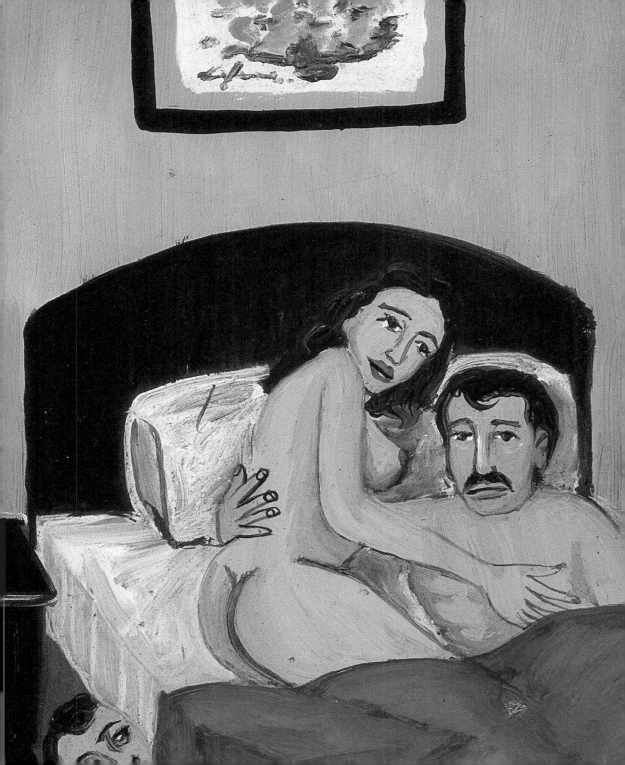

I give you thanks, Sweet Virgin of Guadalupe, that my husband doesn't beat me anymore. I prayed to you so hard, and you granted me this, and now we love each other so much, and I am very happy. I come now to give you thanks. María T——. Toluca, Mexico. May 10, 1970.

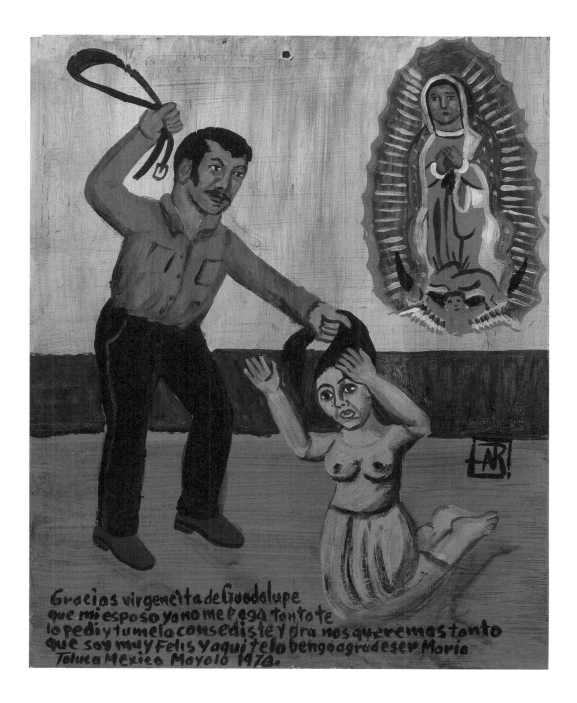

Gracias virgencita de Guadalupe
que mi esposo ya no me pega tanto te
lo pedi y tu melo consediste y ora nos queremas tanto
que soy muy Felis y aqui te la bengo agradeser Maria
Toluca Mexico Mayo 10 1974.

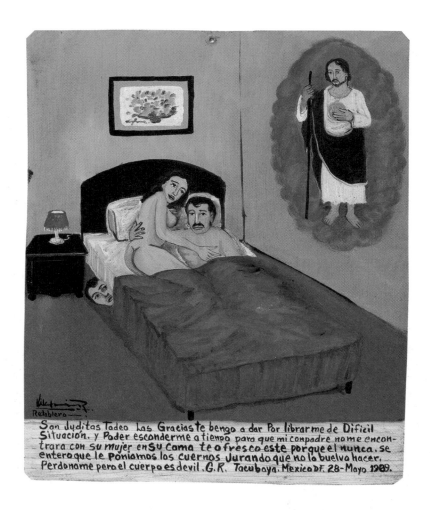

San Juditas Tadeo Las Gracias te bengo a dar Por librarme de Dificil Situación. y Poder esconderme a tiempo para que mi conpadre no me encontrara con su mujer en su Cama te ofresco este porque el nunca, se entero que le Poniamos los cuernos Jurando que no la buelva hacer. Perdoname pero el cuerpo es devil. G.R. Tacubaya. Mexico D.F. 28-Mayo 1989.

San Judás Tadeo, I come to give you thanks for getting me out of a difficult situation and managing to hide me in time so my pal didn't find me with his wife in their bed. I offer you this, swearing I won't do it again, because he never found out he got two-timed. Forgive me, but the body is the devil. G.R. Tacubaya, Mexico D.F. May 28, 1989.

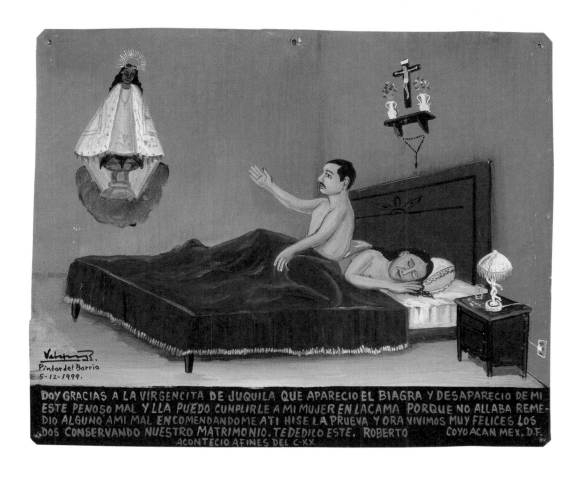

I give thanks to the Sweet Virgin of Juquila for Viagra, and that my sad ailment went away and now I can perform with my wife in bed, because I could find no cure for my ailment, and entrusting myself to you I tried it, and now we are both very happy and our marriage has been saved. I dedicate this to you. Roberto P——. Coyoacán, Mexico D.F. This happened at the end of the 20th century.

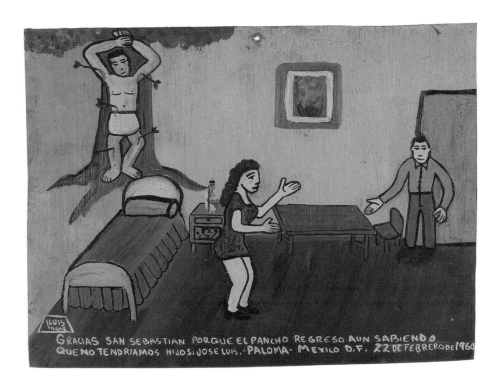

GRACIAS SAN SEBASTIAN PORQUE EL PANCHO REGRESO AUN SABIENDO QUE NO TENDRIAMOS HIJOS. JOSE LUIS. PALOMA. MEXICO D.F. 22 DE FEBRERO DE 1960

Thank you, San Sebastián, because Pancho came back to me, even though he knows we can't have children. Paloma. Mexico D.F. February 22, 1960.

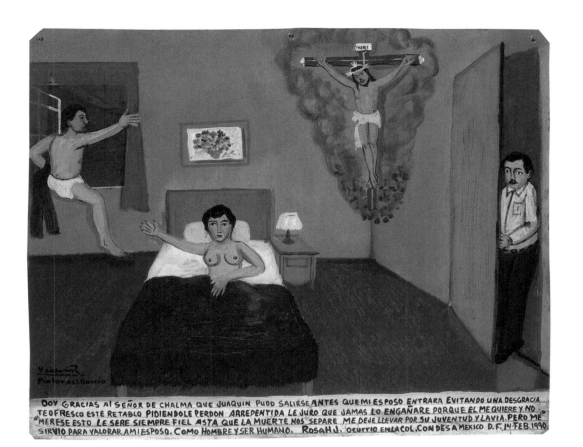

DOY GRACIAS AL SEÑOR DE CHALMA QUE JUAQUIN PUDO SALIRSE ANTES QUE MI ESPOSO ENTRARA EVITANDO UNA DESGRACIA TE OFRESCO ESTE RETABLO PIDIENDOLE PERDON ARREPENTIDA LE JURO QUE JAMAS LO ENGAÑARE PORQUE EL ME QUIERE Y NO MERESE ESTO LE SERE SIEMPRE FIEL ASTA QUE LA MUERTE NOS SEPARE ME DEJE LLEVAR POR SU JUVENTUD Y LA VIA. PERO ME SIRVIO PARA VALORAR A MI ESPOSO. COMO HOMBRE Y SER HUMANO. RosaH.J. OCURRIO EN LA COL. CONDESA MEXICO D.F. 14 FEB. 1990.

I give thanks to Lord Jesus of Chalma that Joaquín was able to get away before my husband came in, avoiding a disaster. I offer Him this retablo, begging His forgiveness. I swear in remorse never to cheat [again], because my husband loves me and doesn't deserve it. I will always be faithful to him till death do us part. I let myself get carried away by [Joaquín's] youth and smooth talk, but this has made me appreciate my husband, as a man and a human being. Rosa H. J. This took place in Col. Condesa, Mexico D.F. February 14, 1990.

Blessed Virgin of Guadalupe, thank you for protecting me when I was threatened by a drunk who said he was a powerful man. When I refused to dance with him he pulled out a pistol, and a young man, seeing the drunk so fixated, risked his own life and started dancing with me, shielding me with his body so I wouldn't get hurt. I give thanks because this is my work, and it's the way I earn a living. Blessed art thou. Marta G——. This happened in the Cabaret San Francisco. December 15, 1972.

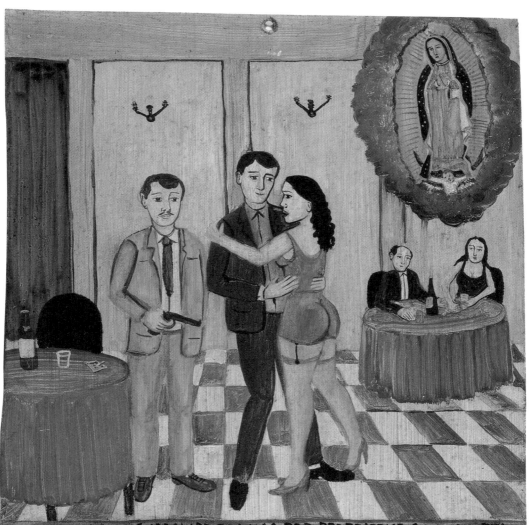

VIRJENSITA DE GUADALUPE GRACIAS POR PROTEJERME CUANDO FUI
AMENASADA POR BORRACHO QUE SE DESIA INFLUYENTE AL NEGARME A
BAILAR CON EL SACO SU PISTOLA Y UN MUCHACHO ALBERLO TAN TERCO SE
ARRIESGO ME SACO A BAILAR PROTEJIENDOME CON SU CUERPO EVITANDO.
ME ISIERA DAÑO. DOY LAS GRACIAS PORQUE ESTE ES MI TRABAJO.
Y ASI ME GANO LA VIDA BENDITA SEAS MARTA
ACONTESIO EN EL CABARET SAN FRANCISCO EL 15 DE DICIENBRE DE 1972.

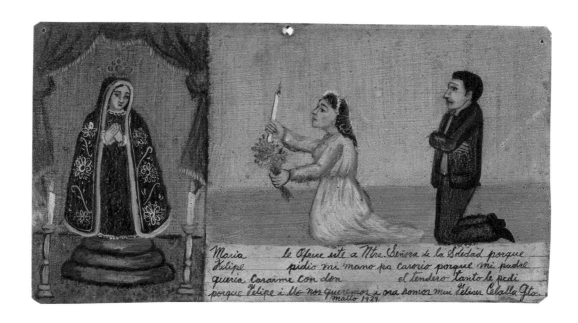

María P—— offers this to Our Lady of Solitude because Felipe G—— asked for my hand in marriage, because my father wanted to marry me off to Don P—— the shopkeeper. I prayed so hard for this because Felipe and I love each other, and now we are very happy. Celaya, Guanajuato. May 1929.

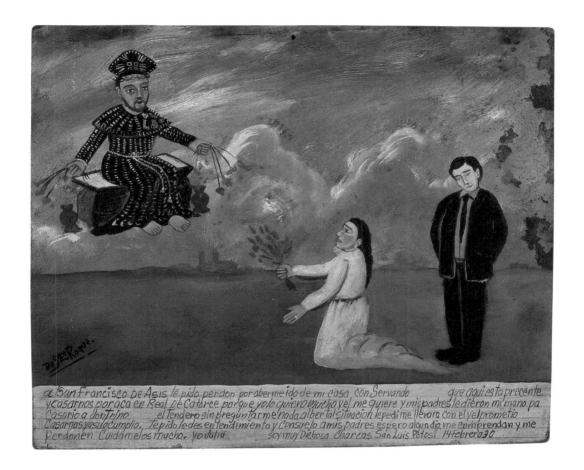

a San Francisco de Asís le pido perdon por aberme ido de mi casa con Servando que aqui esta precente y casarnos por aca en Real De Catorce porque yo lo quiero mucho y el me quiere y mis padres le dieron mi mano pa Casorio a don Trino el Tendero sin preguntarme nada al ber tal Situacion le pedi me llevara con el y el prometio Casarnos y se lo cumplio. Te pido le des entendimiento y Consuelo a mis padres espero algundia me comprendan y me Perdonen Cuidamelos mucho. yo Julia soy muy Dichosa Charcas San Luis Potosí 14 febrero 90

I beg forgiveness from San Francisco de Asís for leaving home with Servando C——, who is present here, and getting married here to him in Real de Catorce, because I love him very much and he loves me, and my parents gave my hand in marriage to Don Trino P—— the shopkeeper without even asking me. Finding myself in this situation, I asked him to take me away with him and he promised we would get married, and we did. I pray you to give understanding and comfort to my parents. I hope someday they will understand and forgive me. Take good care of them for me. I, Julia C——, am very happy. Charcas de San Luis Potosí. February 14, 1990.

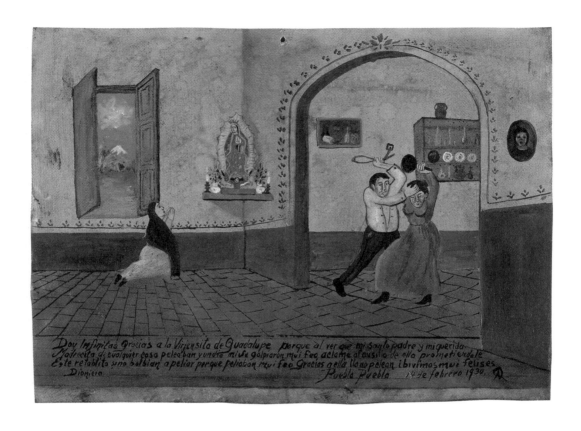

I give infinite thanks to the Sweet Virgin of Guadalupe, because my blessed father and my beloved mother would start fighting over anything at all, and one day when they were hitting each other really badly I appealed to her, promising her this retablo if they would not fight anymore, because they were fighting really bad. Thanks to her, they don't fight anymore and our lives are very happy. Dionisia C—— del R——. Puebla, Puebla. February 14, 1930.

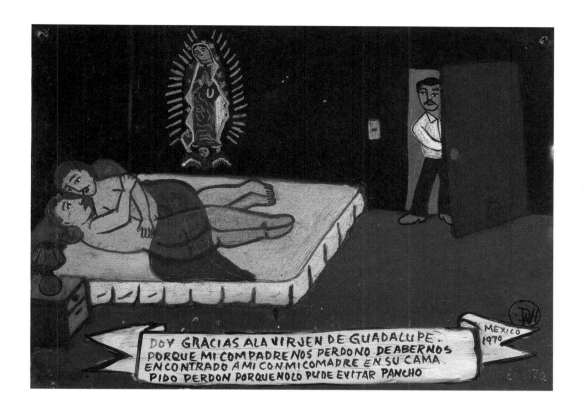

I give thanks to the Virgin of Guadalupe that my good friend forgave us after he found me in his bed with his wife. I beg forgiveness, because I couldn't help it. Pancho C——. Mexico. 1970.

NATURAL DISASTERS

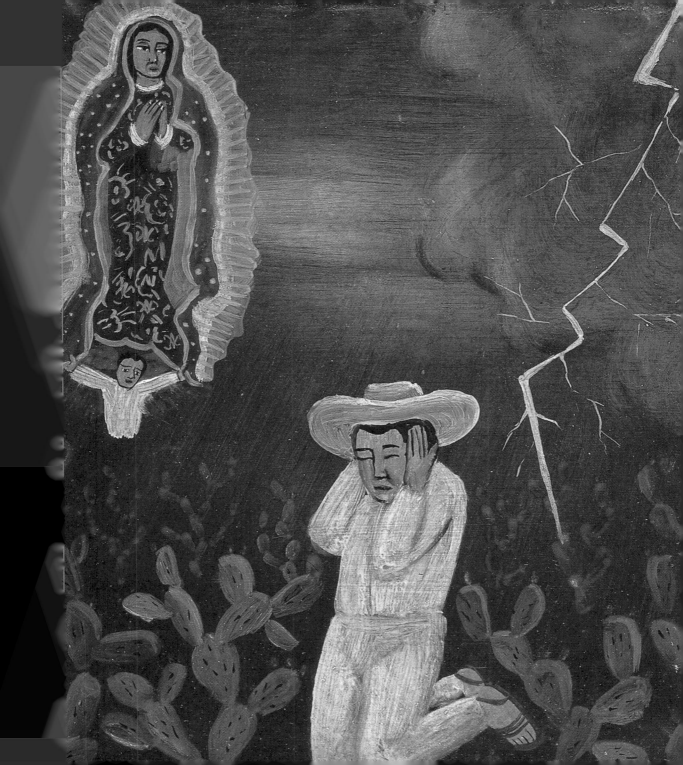

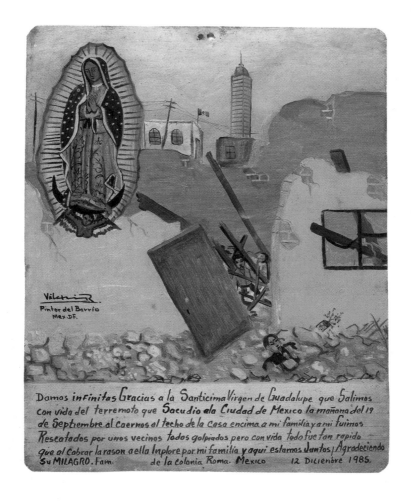

Damos infinitas Gracias a la Santicima Virgen de Guadalupe que Salimos
con vida del terremoto que Sacudio a la Ciudad de Mexico la mañana del 19
de Septiembre al caernos el techo de la casa encima a mi familia y a mi fuimos
Rescatados por unos vecinos todos golpiados pero con vida todo fue tan rapido
que al Cobrar la rason a ella Inplore por mi familia y aqui estamos Juntos, Agradeciendo
Su MILAGRO. Fam. de la colonia Roma. Mexico 12 Diciembre 1985.

We give infinite thanks to the Most Holy Virgin of Guadalupe that we got out alive from the earthquake that hit Mexico City the morning of September 19, when the roof of our house fell on my family and me and we were rescued by neighbors, battered but alive. It all happened so fast, and when I regained consciousness I prayed to her for my family, and here we are together, thanking her for this miracle. M—— family. Colonia Roma, Mexico. December 12, 1985.

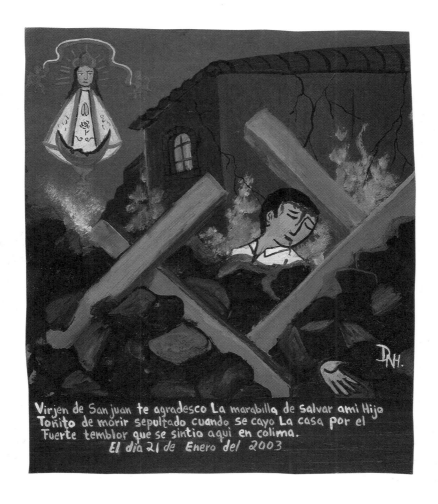

Virjen de San juan te agradesco La marabilla de salvar ami Hijo Toñito de morir sepultado cuando se cayo La casa por el Fuerte temblor que se sintio aqui en colima. El dia 21 de Enero del 2003

Virgin of San Juan, I thank you for the marvel of saving my son Toñito from being crushed to death when our house collapsed in the severe earthquake we had here in Colima. 21st day of January 2003.

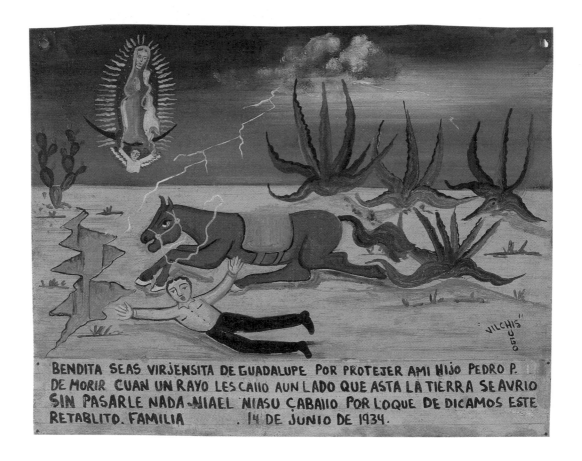

BENDITA SEAS VIRJENSITA DE GUADALUPE POR PROTEJER AMI HIJO PEDRO P. DE MORIR CUAN UN RAYO LES CAIIO AUN LADO QUE ASTA LA TIERRA SE AVRIO SIN PASARLE NADA-NIAEL NIASU CABAIIO POR LOQUE DE DICAMOS ESTE RETABLITO. FAMILIA . 14 DE JUNIO DE 1934.

Blessed art thou, Virgin of Guadalupe, for shielding my son Pedro from death when a lightning bolt struck right next to him so powerful that it made a hole in the ground, and nothing happened to him or his horse. For this we dedicate this retablo to you. P—— family. June 14, 1934.

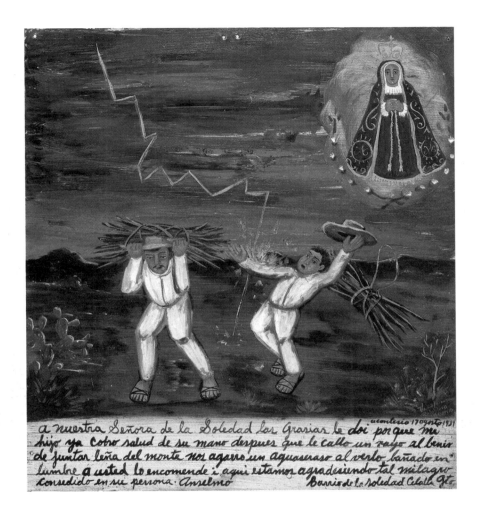

To Our Lady of Solitude I give thanks because my son's hand has healed now after he was struck by lightning as we returned from gathering firewood in the hills and were caught in a downpour. When I saw him bathed in fire I entrusted him to you, and we come now to thank you for this miracle granted to his person. Anselmo H——. Barrio de la Soledad. Celaya, Guanajuato.

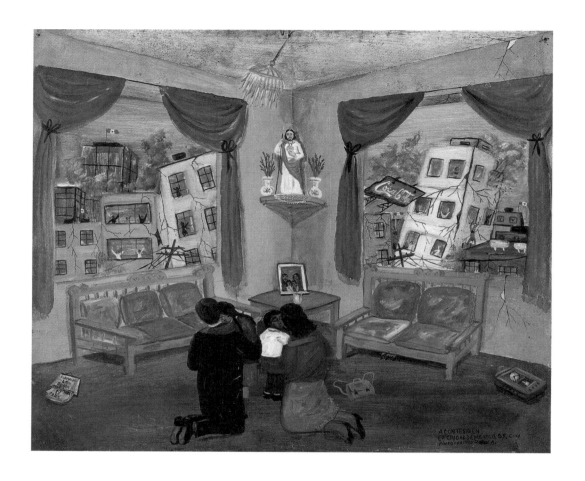

This took place in Mexico City. 20th century.

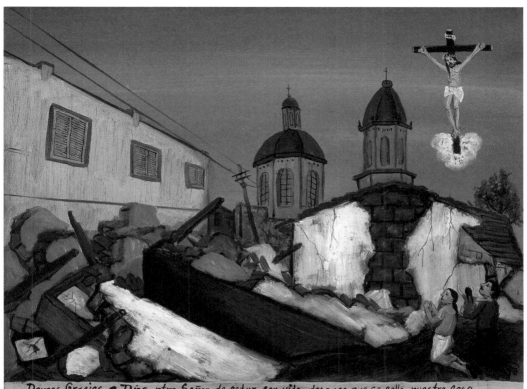

Damos Gracias a Dios ntro Señor de estar con vida, despues que se callo nuestra casa.
Perdiendo lo poco que teniamos que con tanto esfuerso lo juntamos y asi lo perdimos por el temblor del martes
21 de Enero alas 8os de la noche que fue de 7.6 grados Richter aqui en Colima dejando muchas casas en ruinas y
Varios muertitos, Bendice nuestro Pueblo y libralo de Otro igual familia Agradecida Febrero-2-2003 Pinto Valdes
 Ándores del Pueblo

We give thanks to the Lord God that we are alive after our house fell down. We lost the little we had, which we had collected with so much effort, and then we lost it in the earthquake of Tuesday, January 31 at 8:05 at night, which was 7.6 degrees Richter, here in Colima, leaving many houses in ruins and causing several deaths. Bless our town and deliver it from another earthquake like this one. A thankful family. February 2, 2003.

PARENTHOOD

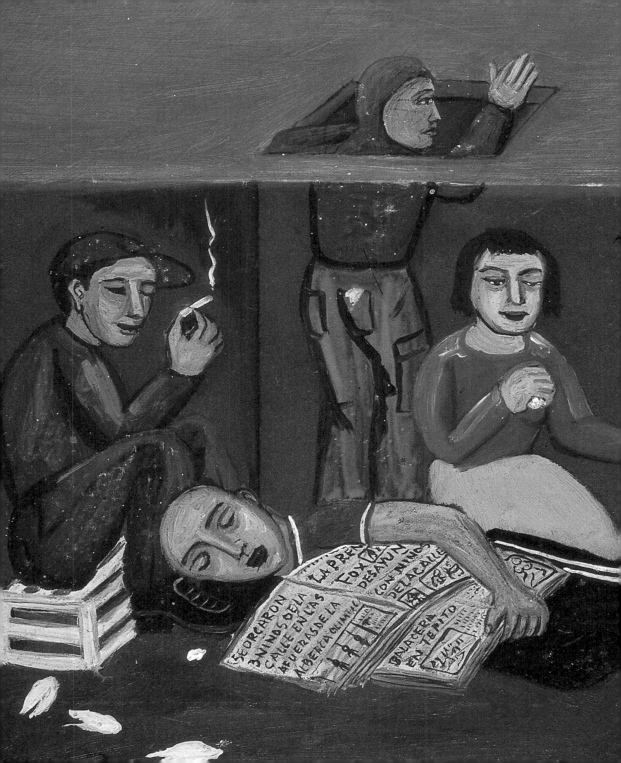

Sacred Jesus of Chalma, I dedicate this retablo to you because my sister was able to give birth to her baby and they both came through it safely. Luis Angel Vilchis. Mexico Distrito Federal. December 24, 2000.

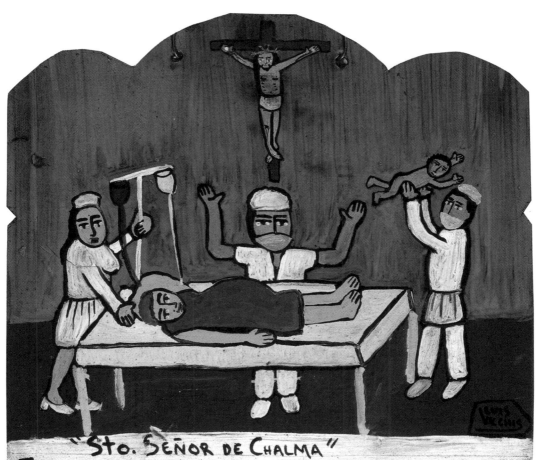

"Sto. Señor de Chalma"
TE DEDICO ESTE RETABLITO PORQUE MI HERMANA
PUDO PARIR A SU HIJO Y SALIERON LOS DOS CON
VIEN. LUIS ANGEL VILCHIS. MEXICO Distrito Federal.
24 de DICIEMRE DEL 2000.

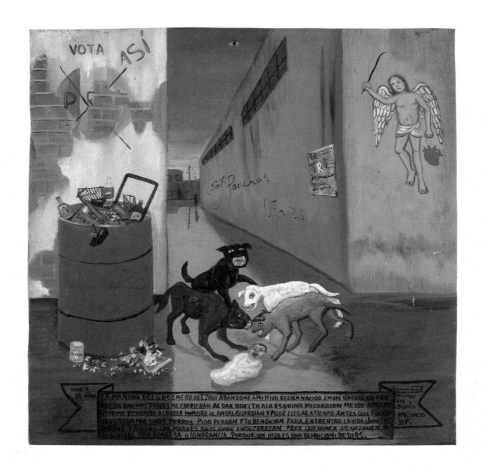

María, 15 years old

On the morning of January 6, 2001, I abandoned my newborn baby in a trash can for fear my parents would throw me out. When I got to the corner, my heart made me repent. I started running, praying to the Guardian Angel, and I was able to get there in time before he was eaten by dogs. I beg forgiveness and your blessing to face life together, the two of us, and may you grant all mothers love in their hearts, so they never abandon their children out of poverty or ignorance, because a child is a blessing from God. Neighborhood painter. Mexico D.F.

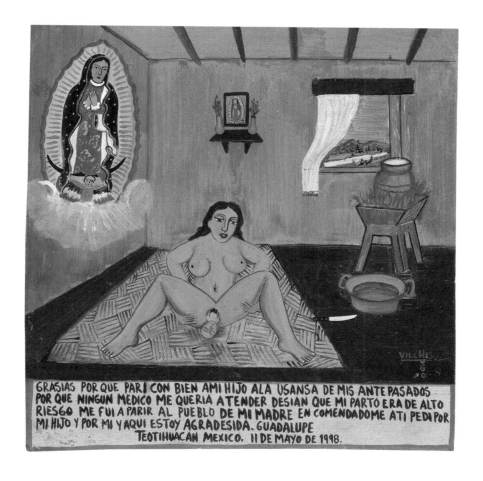

GRASIAS POR QUE PARI CON BIEN AMI HIJO ALA USANSA DE MIS ANTE PASADOS POR QUE NINGUN MEDICO ME QUERIA ATENDER DESIAN QUE MI PARTO ERA DE ALTO RIESGO ME FUI A PARIR AL PUEBLO DE MI MADRE EN COMENDADOME ATI PEDI POR MI HIJO Y POR MI Y AQUI ESTOY AGRADESIDA. GUADALUPE
TEOTIHUACÁN MEXICO. 11 DE MAYO DE 1998.

Thank you because I gave birth to my baby safely the way my ancestors did, because no doctor would give me care—they said my pregnancy was too high-risk. I went to give birth in my mother's village, and entrusting myself to you I prayed for my baby's life and mine, and here I am to give thanks. Guadalupe S——. Teotihuacán, Mexico. May 11, 1998.

While I was washing clothes for my employers I left my son Nicolás playing with his ball in the rooftop bedroom, and when I heard him crying I ran upstairs and found him being bitten by rats. Seeing this, I appealed to San Judás Tadeo. I took him to the Red Cross and he was cured and delivered from being stricken with rabies. I offered to bring this in eternal gratitude. Nicolasa G——. Colonia José María Pino Suárez. March 28, 1970.

My wife fell down the stairs when she was pregnant and was in danger of miscarrying my baby twins. In this moment I prayed to you for her and my little twins. I promised you this and here we are, with much gratitude. Juan D——. Tacuba, Mexico. 1980.

Dr. Socorro R—— gives thanks to the Virgin of Guadalupe for the good fortune of becoming pregnant after seven years of wanting to so much, because her husband was going to leave her, and now he loves me very much. Blessed art thou. Colonia Roma, Mexico D.F. 1999.

With this retablo we come to give thanks to the Sweet Virgin of Guadalupe for the miracle she worked when our two-day-old daughter was stolen from us in the city hospital by a woman dressed as a nurse on the morning of December 27, 2001. When we had no word during a month that was torture for us, we begged her help in finding [our child]. Never losing faith, we prayed day and night and at last she was brought back to us safe and sound, and will bear the name Axiel Camila. Your faithful servants, Verónica F—— and Oscar A—— C——. Mexico D.F. January 2002.

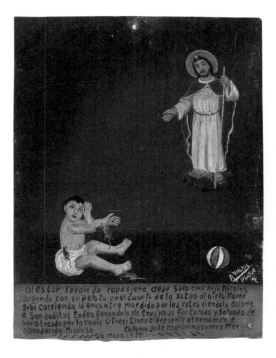

al estar lavando ropa ajena deje solo a mi hijo Nicolas jugando con su pelota en el cuarto de la sotea al oirlo llorar subi corriendo lo encontre mordido por las ratas viendolo aclame a San Judas Tadeo llevandolo a la Cruz Roja fue curado y salvado de ser atacado por la rovia ofresi traer el presente eternamente agradecida Nicolasa Colonia Jose MariaPinoSuarez Mex 26 mayo 1970

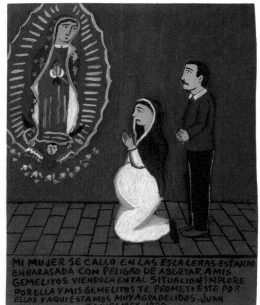

MI MUJER SE CALLO EN LAS ESCALERAS ESTANDO ENBARASADA CON PELIGRO DE ABORTAR A MIS GEMELITOS VIENDOLA EN TAL SITUACION INPLORE POR ELLA Y MIS GEMELITOS TE PROMETI ESTE POR ELLOS Y AQUI ESTAMOS MUY AGRADECIDOS. JUAN TACUBA MEX. 1980.

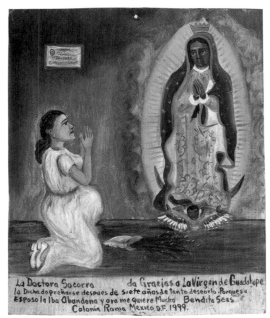

La Doctora Socorro da Gracias a La Virgen de Guadalupe la Dicha de preñarse despues de siete años de tanto desearlo Porque su Esposo la Iba Abandona y ora me quiere Mucho Bendita Seas Colonia Rama Mexico D.F. 1999.

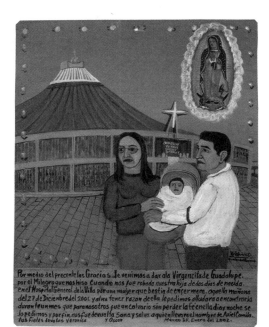

Por medio del precente les Gracias. les venimos a dar a la Virgencita de Guadalupe por el Milagro que nos hiso Cuando nos fue robada nuestra hija de dos dias de nacida en el Hospital General de la Villa por una mujer que bestia de enfermera. aquella mañana del 27 de Diciembre del 2001. y al no tener razon de ella le pedimos a lludara a encontrarla duran te un mes que para nosotros fue un calvario sin perder la fe en ella dia y noche se lo pedimos y por fin nos fue devuelta Sana y salva a quien llevra el nombre de Axiel Comila. Tus Fieles devotos Veronica y Oscar Mexico D.F. Enero del 2002.

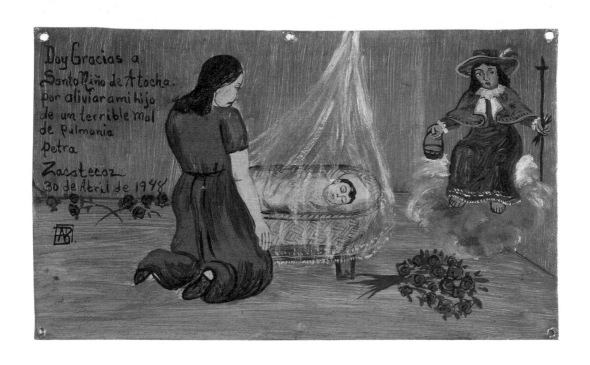

I give thanks to the Holy Infant of Atocha for curing my son of a serious case of pneumonia. Petra C——. Zacatecas. April 30, 1998.

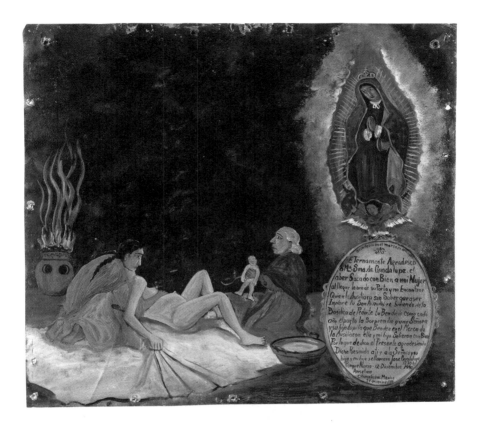

This took place in the [. . .] market.

I am eternally grateful to the Most Holy Virgin of Guadalupe for keeping my wife safe when the moment came for her to give birth and she had no one to help her, and, not knowing what to do, I appealed to your sacred name. We were coming back from the Basilica, where we asked your blessing as we do every year, when the birthing time suddenly arrived, and a lady and her daughter, Lupita, who sell in the market, helped her. She and my son came through safely, for which I dedicate this, in thanks for our good fortune, to you and to the lady and her daughter, and my son will be named José Guadalupe, because he was born December 12,* 1930, at 12:30. Anselmo R—— M——, Chimalistac, Mexico. December 24, 1930.

*December 12 is the feast day of the Virgin of Guadalupe.

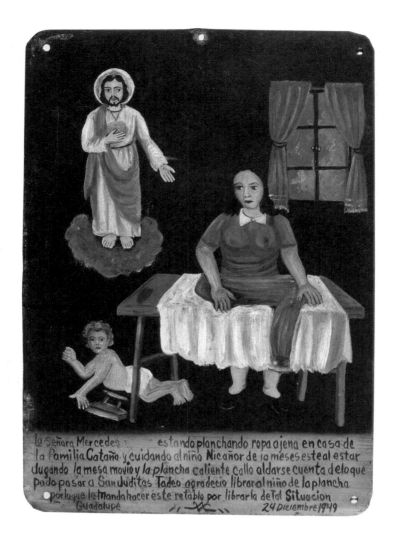

la Señora Mercedes: estando planchando ropa ajena en casa de
la Familia Cataño y cuidando al niño Nicañor de 10 meses este al estar
Jugando la mesa movio y la plancha caliente callo al darse cuenta de lo que
pudo pasar a San Juditas Tadeo agradecio librar al niño de la plancha
porlo que le manda hacer este retable por librarla de Tal Situacion
Guadalupe 24 Diciembre 1949

Señora Mercedes G— was at work ironing clothes at the home of the C— family and watching their son Nicanor, 10 months old, and as he was playing he bumped the table and the hot iron fell down. Realizing what could have happened, she gave thanks to San Judás Tadeo for delivering the child from the iron. I am having this retablo made for delivering him from that situation. Guadalupe Tepeyac. December 24, 1949.

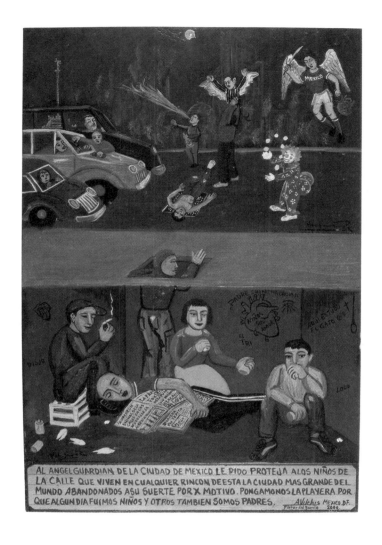

I pray the Guardian Angel of the city of Mexico to protect the street children who live wherever they can in this, the biggest city in the world, abandoned to their fate for X reason. Let's put ourselves in their shoes, because we were all children once, and some of us are parents, too. A. Vilchis, neighborhood painter. Mexico D.F. 2000.

ACCIDENTS

When Juanita was on the swing the rope broke, and she fell and hit her head. When her mama got there and found her bleeding from the head, she was frightened because she wasn't getting up, so she appealed to the Sweet Virgin of San Juan, and at that moment she came to. For this she is having a retablo made in humble gratitude, because [the Virgin] came to the aid of her daughter. Isidra I——. To make it known to her faithful servants. San Juan de los Lagos, Jalisco. April 30, 1950.

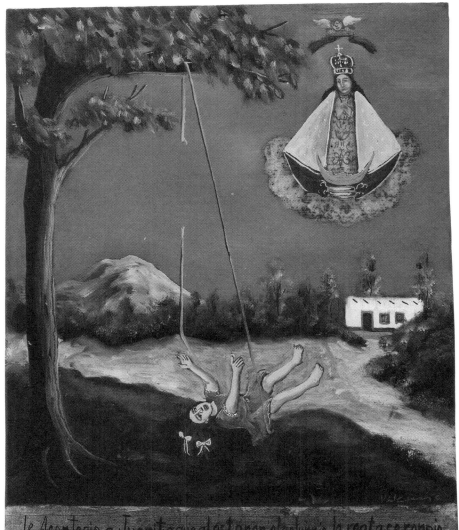

Le Acontecio a Juanita que al estar en el columpio la reata se ronpio
y al caerse la cabesa se ronpio y al llegar su Mama pribado la encontro
Echando Sangre por la cabesa Asustada al berla priemo se le boltia ya
A la Virjencita de San Juan Aclama y al momento despierta por lo que le
Mando Haser este Retablo Como Humilde Agradesimiento porque a su Hijo
Socorria. Isidra Para Savienda de sus fieles Devotos.
San Juan de los Lagos Jalisco 30-Abiil-1950

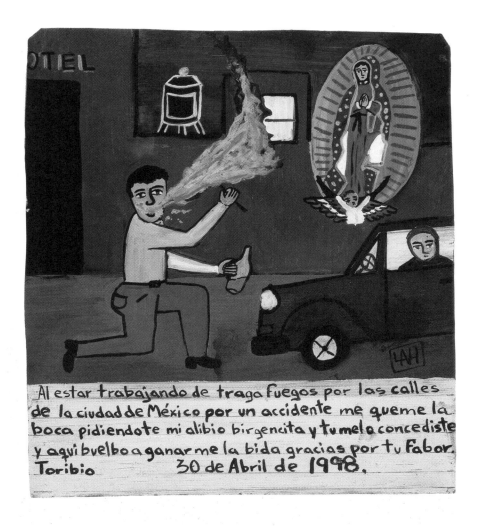

Al estar trabajando de traga fuegos por las calles de la ciudad de México por un accidente me queme la boca pidiendote mi alibio birgencita y tu me la concediste y aqui buelbo a ganarme la bida gracias por tu Fabor. Toribio 30 de Abril de 1998.

While working as a fire eater in the streets of Mexico City I accidentally burned my mouth. I prayed to you to heal me, Virgin, and you granted this, and here I am, back to earning my living. Thank you for your grace. Toribio G——. April 30, 1998.

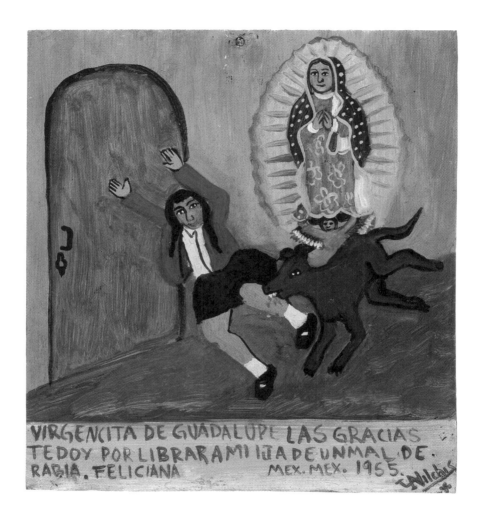

Virgin of Guadalupe, I give you thanks for keeping my daughter from catching rabies. Feliciana S——. Mexico, Mexico. 1955.

In gratitude to the Brown-skinned Lady of Tepeyac I dedicate this retablo for granting me my voice after I had lost it for a period of thirty-seven days. Finding no cure, I entrusted myself to her and now I am singing again here in Garibaldi, where I earn my living with my voice. In gratitude, I hereby vow to come and sing her "Las Mañanitas"* on her feast day, as long as I live. Santiago H——, a mariachi heart and soul. Mexico. 1980.

*The equivalent of "Happy Birthday"

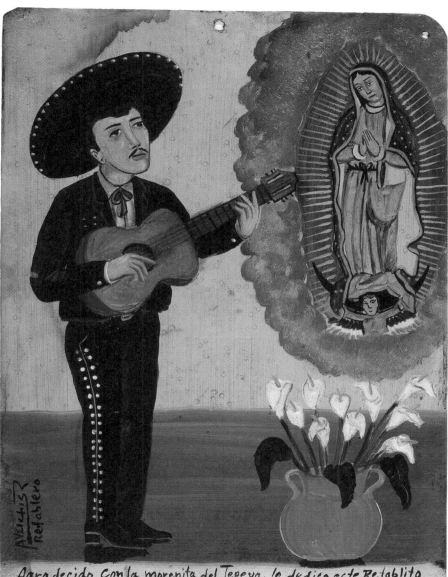

Agradecido Con la morenita del Tepeya. le dedico este Retablito
por Conseder me mi vos despues de aberla perdido por espasio de treinta
y siete dias sin encontrar cura a mi mal a ella me encomende y buelbo
a cantar aqui en Garibaldi donde me gano la vida con mi bos Agradecido
le prometo por medio del presente benirle a cantar sus mañanitas Cada dia
de su Santo mientras vivo. Santiago Mariachi de Corazon Mex 1980.

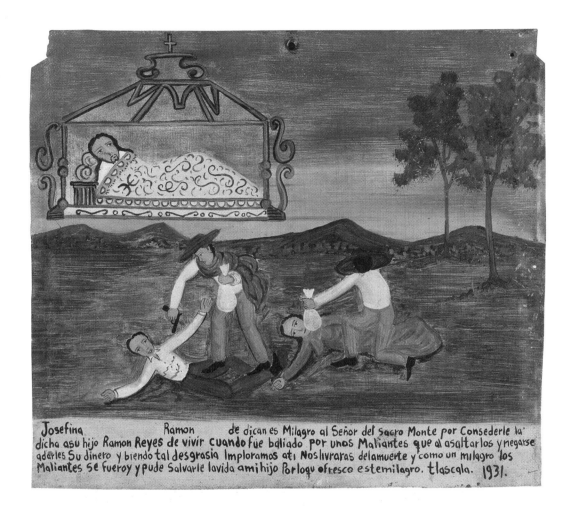

Josefina Ramon de dican es Milagro al Señor del Sacro Monte por Consederle la
dicha asu hijo Ramon Reyes de vivir cuando fue baliado por unos Maliantes que al asaltarlos y negarse
adarles Su dinero y biendo tal desgrasia Imploramos ati Noslivraras delamuerte y como un milagro los
Maliantes se fueroy y pude Salvarle lavida amihijo Porloqu ofresco estemilagro. tlascala. 1931.

Josefina R—— and her son Ramón R—— dedicate this *milagro* to Lord Jesus of the Mountain for safeguarding the life of her son Ramón R—— after he was shot by some ruffians who attacked them and he wouldn't give them his money. In our misfortune we prayed to you to deliver us from death, and as though by miracle the ruffians ran away and I was able to save my son's life. For this I offer this *milagro*. Tlaxcala. 1931.

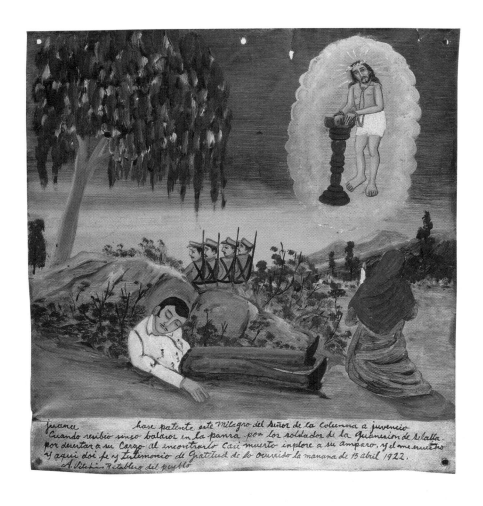

Juana H—— makes known this miracle worked by Our Lord of the Column for Juvencio R—— when he took five bullets in the gut from the soldiers of the Celaya garrison because he had deserted his post. Finding him nearly dead, I begged His aid and He heard my prayer. I here bear witness and declare my gratitude for this event on the morning of April 15, 1922.

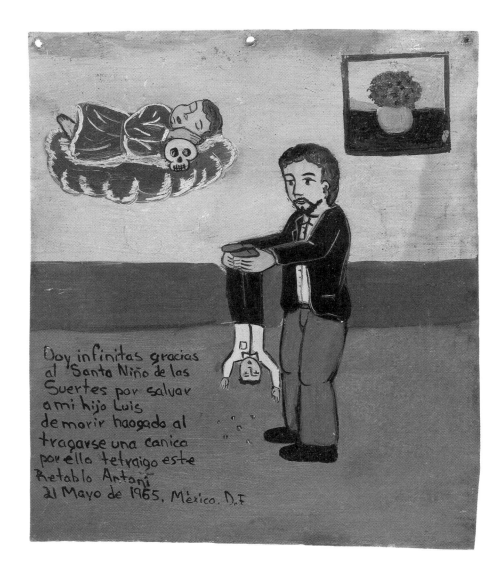

Doy infinitas gracias
al Santo Niño de las
Suertes por salvar
a mi hijo Luis
de morir haogado al
tragarse una canica
por ello te traigo este
Retablo Antoni
21 Mayo de 1965, México. D.F

I give infinite thanks to the Jesus of Luck for saving my son Luis from choking to death when he swallowed a marble. For this I bring you this retablo. Antoni M—— G——. May 21, 1965. Mexico D.F.

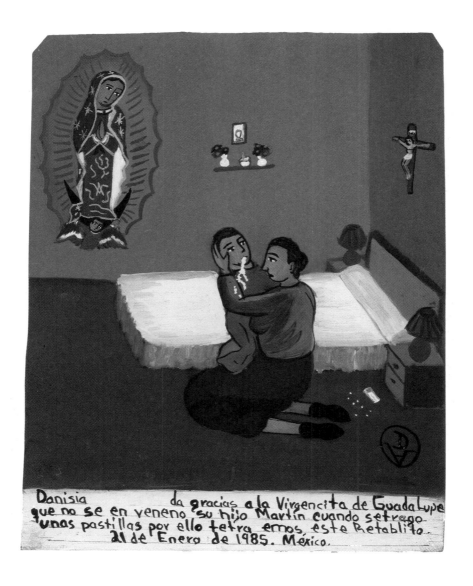

Danisia da gracias a la Virgencita de Guadalupe que no se en veneno su hijo Martin cuando se trago unas pastillas por ello tetra emos este Retablito. 21 de Enero de 1985. México.

Danisia M—— gives thanks to the Virgin of Guadalupe that her son Martín was not poisoned when he swallowed some pills, and for this we bring you this retablo. January 21, 1985. Mexico.

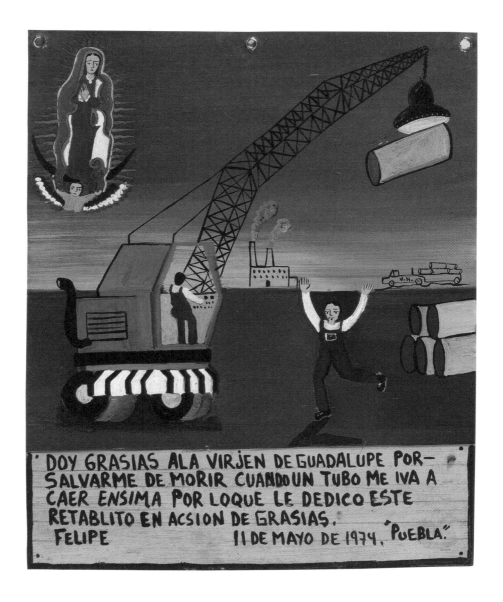

I give thanks to the Virgin of Guadalupe for saving me from death when a pipe nearly fell on top of me. I dedicate to her this retablo as a sign of gratitude. Felipe B——. May 11, 1974. Puebla.

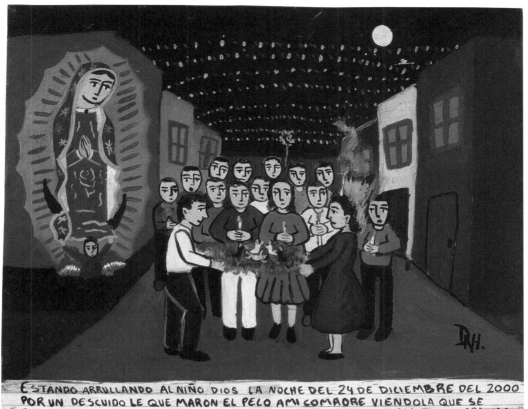

ESTANDO ARRULLANDO AL NIÑO DIOS LA NOCHE DEL 24 DE DICIEMBRE DEL 2000 POR UN DESCUIDO LE QUE MARON EL PELO A MI COMADRE VIENDOLA QUE SE QUE MABA LA EN COMENDE A LA BIRGENCITA DE GUADALUPE Y AQUI DOY GRACIAS QUE NO PASO UNA DESGRACIA. ESPERANZA OLIBAR DEL CONDE MEXICO.

As we sang to the Christ Child on the night of December 24, 2000, my friend's hair accidentally caught fire. When I saw her burning I entrusted her to the care of the Sweet Virgin of Guadalupe, and with this retablo I give thanks that nothing serious happened. Esperanza V——. Olivar del Conde, Mexico.

While hanging the laundry, my daughter Juanita fell from the roof. I appealed to the Most Holy Virgin of San Juan de los Lagos, because she was knocked unconscious, and I prayed she wouldn't die on me. I offer this *milagro* for your grace, because nothing happened to her. Coyoacán, Mexico. Socorro S——. April 30, 2000.

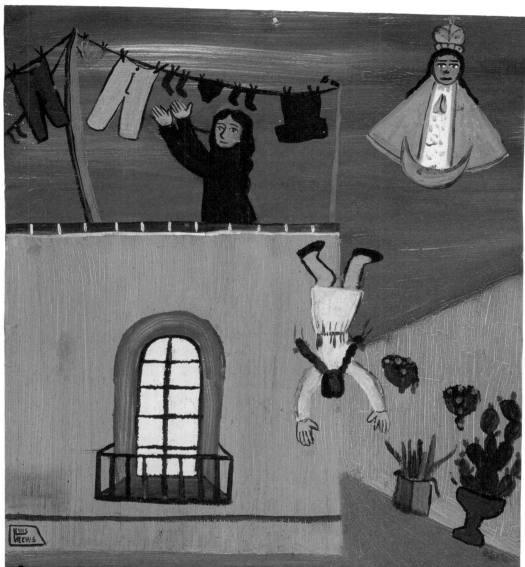

CUANDO TENDIA LA ROPA MI NIÑA JUANITA SE CAYO DE LA ASOTEA ACLAME A LA SANTISIMA
VIRGEN DE SAN JUAN DE LOS LAGOS PORQUE ESTABA PRIBADA SIN RASON Y LE PEDI
NO SE ME FUERA A MORIR O FRESCO ESTE MILAGRITO POR EL RECIBIDO PORQUE
A ELLA NO LE PASO NADA COYOACAN MEXICO. SOCORRO 30 ABRIL 2000

ILLNESS

D. Juana M—— and her son.

When her son fell ill at the age of one year and thirteen days, seeing that there were no remedies and natural medicines were of no benefit, at this chapel before the altar of Lord Jesus of the Column she asked for a glass of holy water. She had him drink it, for by now he was near death. With the tears of a mother's eyes she prayed for charity, seeing him stiff and dying she entrusted him to Our Holy Lord. After he drank the holy water, he soon opened his little eyes and his little hands started moving. The holy water was all used up. Now he has been cured, and his mother, in awe and amazement, is having this *milagro* made for Him. This took place in San Francisco del Rincón, Guanajuato.

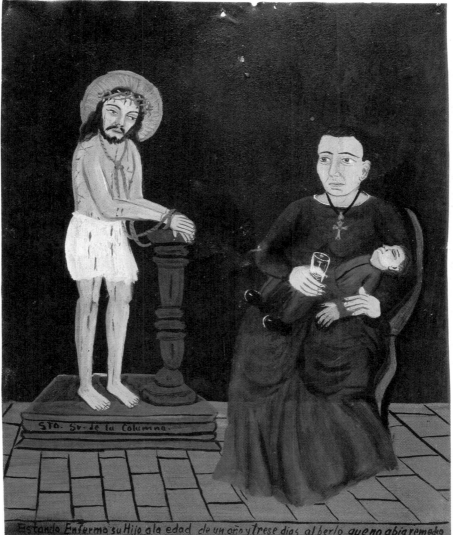

STO. Sr. de la Columna.

Estando Enfermo su Hijo a la edad de un año y trese dias al berlo que no abia remedio
ni Medicinas Naturales te Faborecieran a este oratorio del Señor de la columna ante su Altar
Pidio un vaso de Agua Bendita Hiso se la Tragara por que ya benia casi Muerto con lagrimas en los
ojos de una Madre pidio Caridad que viendola ya Tieso Aganisando al Sato Señor lo encomendo abiendo
Tragado el Agua Bendita luego Abrio los ojitos mobiendo sus manitas el Agua Bendita se acabo Ha sano
quedo Maravillada su Madre temando Hacer este Milagro. Acontesio en San Francisco del Rincon Guanajuato

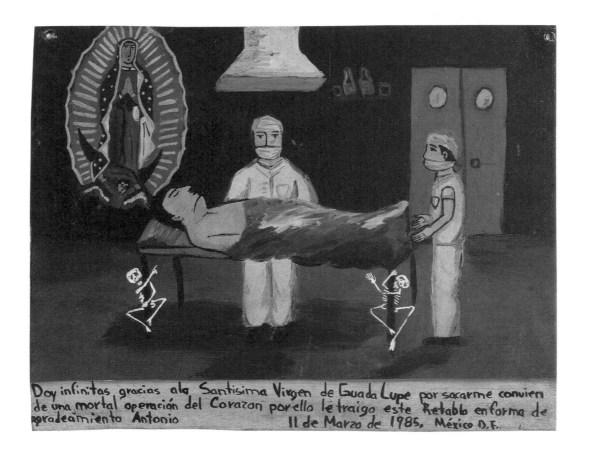

I give infinite thanks to the Most Holy Virgin of Guadalupe for seeing me safely through a life-or-death heart operation. For this I bring you this retablo by way of gratitude. Antonio P—— M——. March 11, 1985. Mexico D.F.

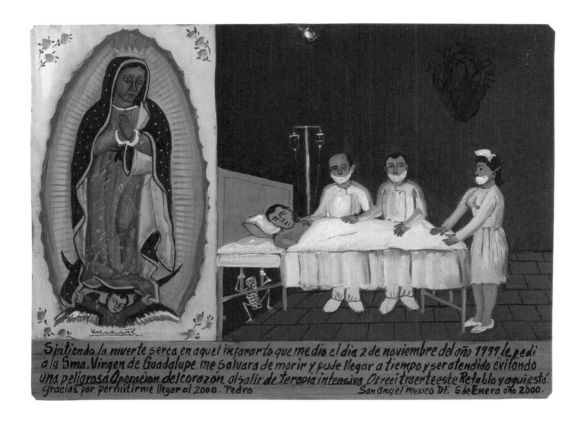

Sintiendo la muerte serca en aquel infararto que me dio el dia 2 de noviembre del año 1999 le pedi a la Sma. Virgen de Guadalupe. me Salvara de morir y pude llegar a tiempo y ser atendido evitondo una peligrosa Operacion del corazón al salir de terapia intensiva. Oreci traerte este Retablo y aquiesta gracias por permitirme llegar al 2000. Pedro San angel mexico DF. 6 de Enero año 2000.

Sensing death very near when I had a heart attack on November 2, 1999, I prayed to the Most Holy Virgin of Guadalupe to save my life, and I got there in time to receive care and avoid a dangerous heart operation after intensive therapy. I offered to bring you this retablo, and here it is. Thank you for letting me make it to 2000. Pedro R——. San Angel, Mexico. January 6, year 2000.

To the Archangel of the Gang, I give thanks for curing me of a disease that seemed like AIDS after I did it with no protection with a chick I didn't know at a party. When I felt sick I was scared and didn't tell anybody. I felt so alone. I only told you, praying you would make it stop. I worked up the courage to face reality and went to a doctor, who told me I had come in time and I escaped this damned disease of the century. Now I feel better, my tests came back negative. Thank the Lord, I'm here to tell about it: To the whole gang, be careful about AIDS. Tacubaya, Mexico. End of the millennium, 20th century.

Señor Jilberto R—— and his wife, Teresa G——, whose baby son a year and three months old was vomiting violently and spitting up blood, appealed for the aid of San Judás Tadeo, offering a retablo when he recovered his health. Now he is healthy and we bring you this. Mixcoac, Mexico. October 28, 1950.

Thanks be to God for granting me another chance to live after I had a very dangerous illness and when I prayed to Him He allowed me to be cured. Rosa C——. Mexico D.F. 1960.

Holy Infant of Atocha, I come to give thanks because now I can walk, after 197 days when I couldn't even stand up by myself. I prayed to you with all my heart, promising this retablo, and my pleas were heard, and here I am to fulfill my vow. Thank you for saving me from losing my legs in a terrible accident. Now I can walk without the crutches. Juan P——. Sombrerete, Zacatecas. June 1930.

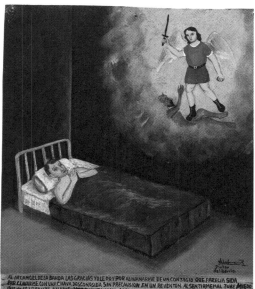

AL ARCANGEL DE LA BANDA LAS GRACIAS YO LE DOY POR ALIVIANARME DE UN CONTAGIO QUE PARECIA SIDA
POR CLAVARME CON UNA CHAVA DESCONOSIDA SIN PRECAUSION EN UN REVENTON. AL SENTIRME MAL TUBE MIEDO
QUE YO SE LO CONTE A NADIE ME SENTI TAN SOLO. SOLO A TI TE LO CONTE PIDIENDO TE ME HISIERAS EL PARO.
DANDOME VALOR DE ENFRENTARME A LA REALIDAD ACUDI A UN MEDICO QUIEN ME DIJO QUE FUI A TIEMPO Y PUDO
EVITAR ESE MALDITO MAL DEL CIGLO. YA ME ALIVIANE MIS ANALISIS SALIERON NEGATIVO. GRACIAS A DIOS
AQUI ME REPORTO POR EL PARO. A TODA LA BANDA CUIDADO CON EL SIDA TACUBAYA MEXICO. FIN DE MILENIO CD.

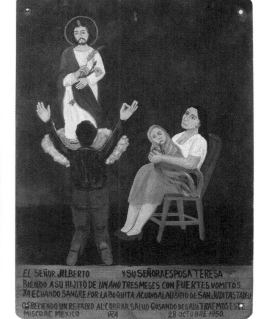

EL SEÑOR JILBERTO Y SU SEÑORA ESPOSA TERESA
BIENDO A SU HIJITO DE UN AÑO TRES MESES CON FUERTES VOMITOS
YA ECHANDO SANGRE POR LA BOQUITA ACUDIO AL AUSIO DE SAN JUDITAS TADE
OFRECIENDO UN RETABLO AL CORRAR SALUD GOSANDO DE SALU TRAEMOS ESTE
MISCOAC MEXICO VRA 28 OCTUBRE 1950.

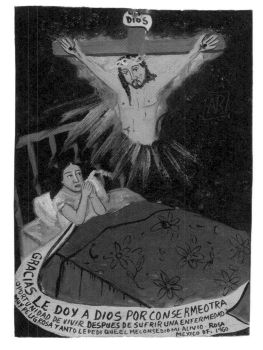

GRACIAS LE DOY A DIOS POR CONSERME OTRA
OPORTUNIDAD DE VIVIR DESPUES DE SUFRIR UNA ENFERMEDAD
MUY PELIGROSA TANTO LE PEDI QUE EL ME CONSEDIO MI ALIVIO. ROSA
MEXICO DF. 1950

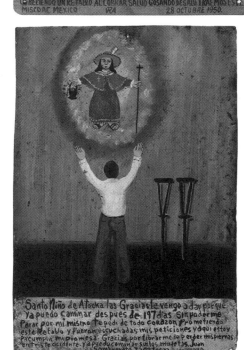

Santo Niño de Atocha las Gracias te vengo a dar porque
ya puedo caminar despues de 197 dias sin poderme
Parar por mi mismo te pedi de todo corazon Prometiendo
este Retablo y Fueran escuchadas mis peticiones y aqui estoy
Pa cumplir mi promesa. Gracias por librarme de Perder mis piernas
en triste accidente. y apuedo caminar sin las muletas. Juan
Sombrerete Zacatecas. junio 1950.

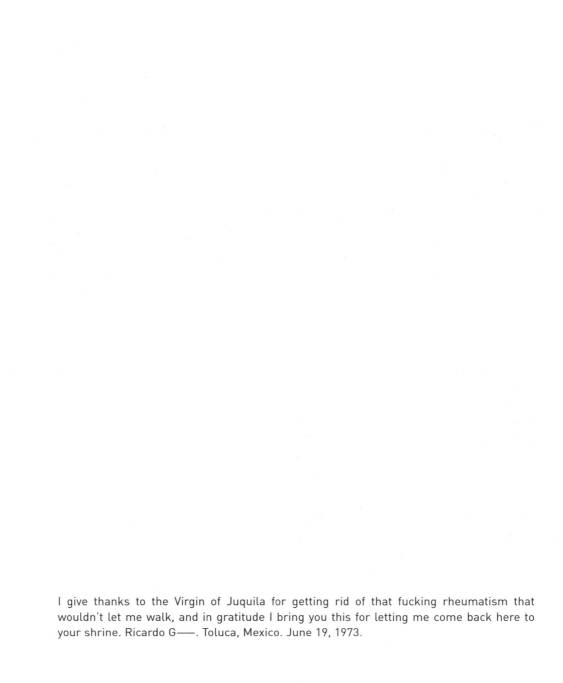

I give thanks to the Virgin of Juquila for getting rid of that fucking rheumatism that wouldn't let me walk, and in gratitude I bring you this for letting me come back here to your shrine. Ricardo G——. Toluca, Mexico. June 19, 1973.

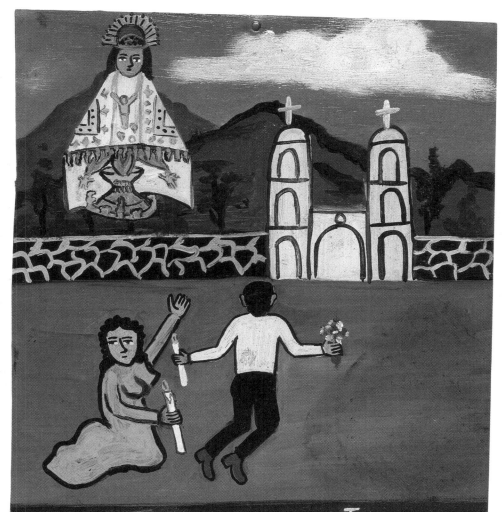

TE DOY LAS GRACIAS BIRGEN DE JUQUILA
POR QUITARME ESTAS PINCHES RIUMAS QUE
NO ME PERMITIAN CAMINAR Y AGRADECIDO
TE TRAIGO ESTE POR PERMITIRME VOLVER
AQUI HASTA TU SANTUARIO. RICARDO
TOLUCA MEXICO. 19 DE JUNIO DE 1973

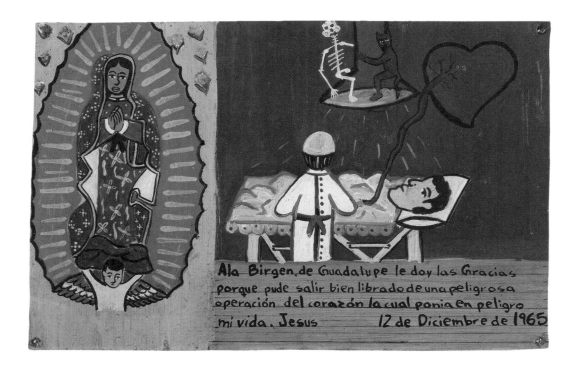

Ala Birgen de Guadalupe le doy las Gracias
porque pude salir bien librado de una peligrosa
operación del corazón la cual ponía en peligro
mi vida. Jesus 12 de Diciembre de 1965

To the Virgin of Guadalupe I give thanks that I came out safely from a dangerous heart operation that put my life in danger. Jesús C——. December 12, 1965.

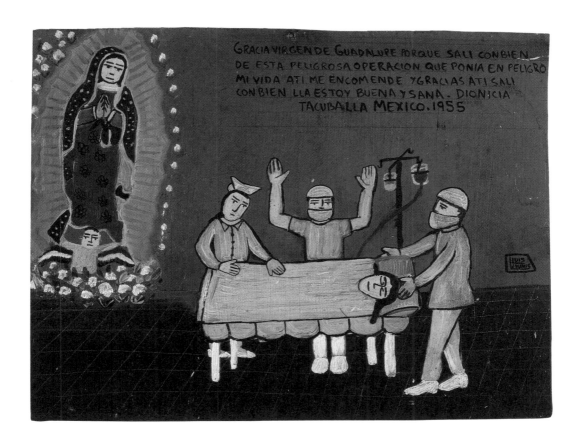

Thank you, Virgin of Guadalupe, because I came out alive after this risky operation that endangered my life. I entrusted myself to you, and by your grace it went well and now I am doing well and in good health. Dionicia M——. Tacubaya, Mexico. 1955.

Estolia B—— places this [retablo] here in thanks for the miracle that happened with Elijio, my brother, who got so sick from getting drunk there was no hope for him. From my truest heart I entrusted it to you to cure him, and here I bear witness to your miracle. Because now that we're orphaned, he takes care of me. Celaya, Guanajuato. January 16, 1925.

Our Mother of Guadalupe, thank you for granting me the good fortune to return alive to my homeland, my beautiful, beloved Mexico, from the United States. I came down with a high fever and was bedridden and near death, unable to work and all alone like a dog, far away from my loved ones. I entrusted myself to you, and when I was well again I came back safely, and with this I show my gratitude for your blessings. Julio C——. Querétaro. December 12, 1950.

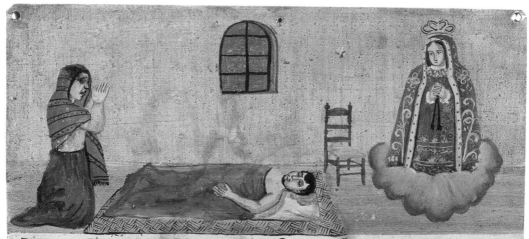

Estalía le pone el presente agradeciendo el Prodijio con Elijio mi hermano que abiendo sido Desausido por un mal a causa de la borrachera conberas de micorason a uste encomende su alivio y aqui doy fe de de su milagro. Porque al quedar huerfanos yo quede a su cuidado. Celaya Guanajuate a 16 Enero 1925.

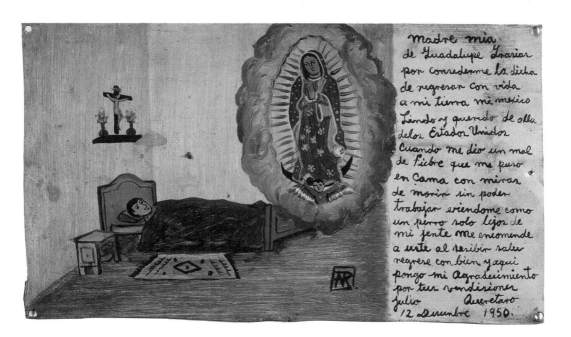

madre mia de Guadalupe Grasias por conrederme la dicha de regresar con vida a mi tierra mi mexico Lindo y querido de alla delos Estados Unidos Cuando me dio un mal de Fiebre que me puso en Cama con miras de morir sin poder trabajar viendome como un perro solo lejos de mi jente me encomende a uste al recibir saler regrese con bien y aqui pongo mi Agradecimiento por tus vendiriones Julio Querétaro 12 Desembre 1950.

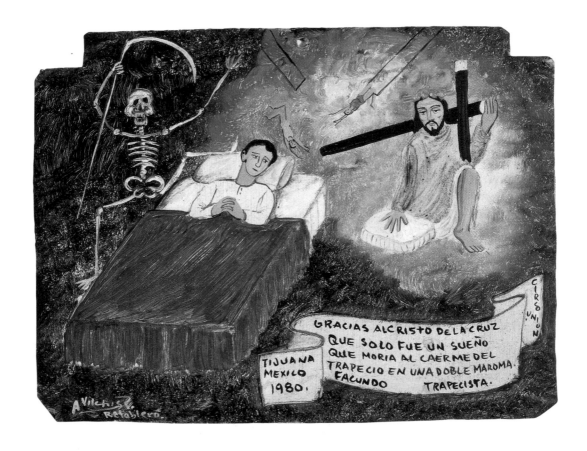

Tijuana, Mexico. 1980. Thanks be to Christ on the Cross that it was only a dream that I fell from the trapeze on a double somersault and died. Facundo P——, trapeze artist. Unión Circus.

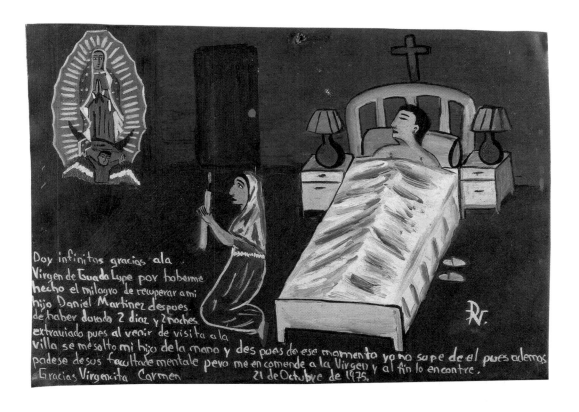

I give infinite thanks to the Virgin of Guadalupe for the miracle of getting back my son, Daniel M——, after he was lost for 2 days and 2 nights. When we came to the city for a visit, I lost hold of my son's hand, and from that moment on I knew nothing more of him, and in addition he does not have all his mental faculties, but I entrusted myself to the Virgin and at last I found him. Thank you, Sweet Virgin. Carmen D—— D——. October 21, 1975.

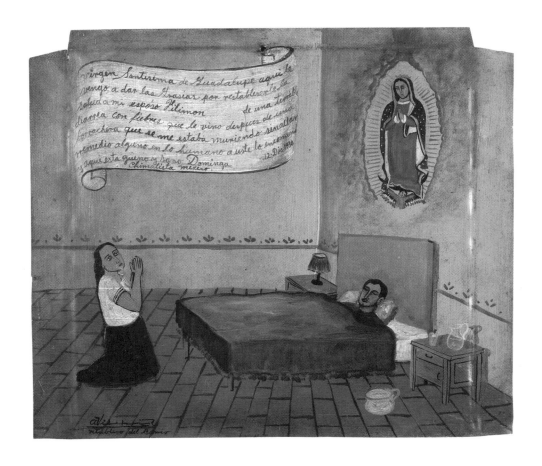

Most Holy Virgin of Guadalupe, I am here to give you thanks for bringing my husband, Filemón R——, back to health after the terrible diarrhea and fevers that struck him when he went on a drinking binge. He was dying, and, finding no human remedy, I entrusted him to you, and now he is well and healthy. Dominga G——. December 12, 1934. Chimalistac, Mexico.

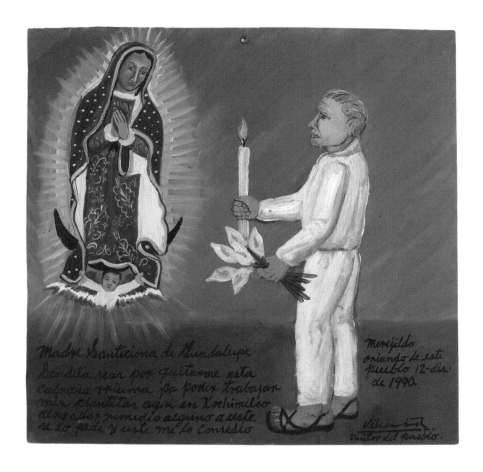

Most Holy Virgin of Guadalupe, blessed art thou for curing that blasted rheumatism so I can work my little crop here in Xochimilco. When I could find no remedy, I prayed to you and you granted my prayer. Merejildo R——, a native of this town. December 12, 1990.

PROSTITUTION

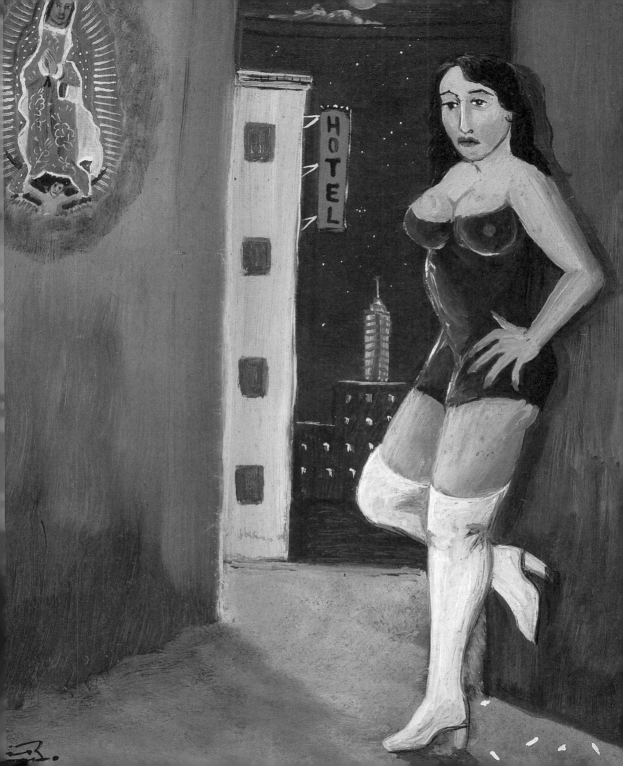

Yolanda H——. I give thanks to the Virgin of Guadalupe that I found work as a prostitute here in La Merced, Mexico. Take good care of me so I can send a few pennies to my parents in Pachuca, Hidalgo. December 12, 1988.

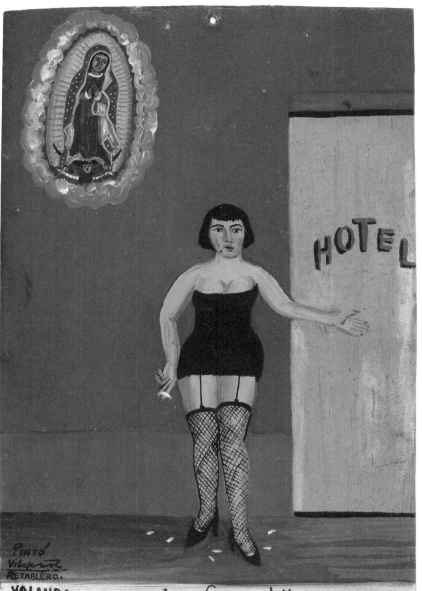

PINTO
Vilaposite
RETABLERO.

YOLANDA LE DOY GRASIAS A La VIRGENCITA DE
GUADALUPE QUE YA ENCONTRE TRABAJO DE PUTA AQUI EN
LA MERCED MEXICO CUIDAME MUCHO PARA PODER MANDARLES UNOS
SENTAVITOS A MIS PADRES ALLA EN PACHUCA HIDALGO. 12 DISIENBRE 1980.

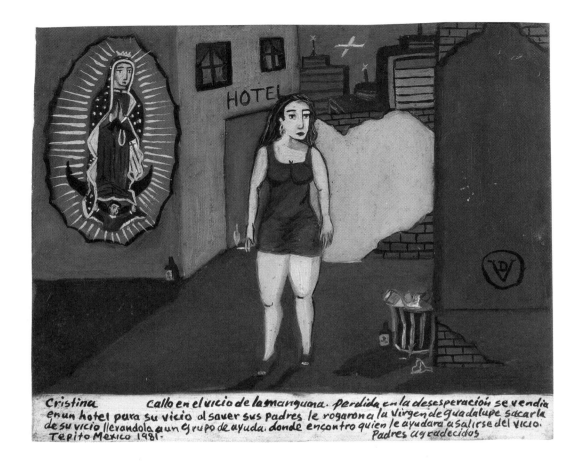

Cristina callo en el vicio de la mariguana. Perdida en la desesperación se vendia en un hotel para su vicio al saver sus padres le rogaron a la Virgen de Guadalupe sacarla de su vicio llevandola a un Grupo de ayuda. donde encontro quien le ayudara a salirse del vicio. Tepito Mexico 1981. Padres agradecidos

Cristina P—— fell into the vice of marijuana. Lost in despair, she was selling herself in a hotel for her vice. When her parents found out, they prayed to the Virgin of Guadalupe to free her from her vice and took her to an aid group, where she found someone to help her get free of her vice. Tepito, Mexico. 1981. Grateful parents.

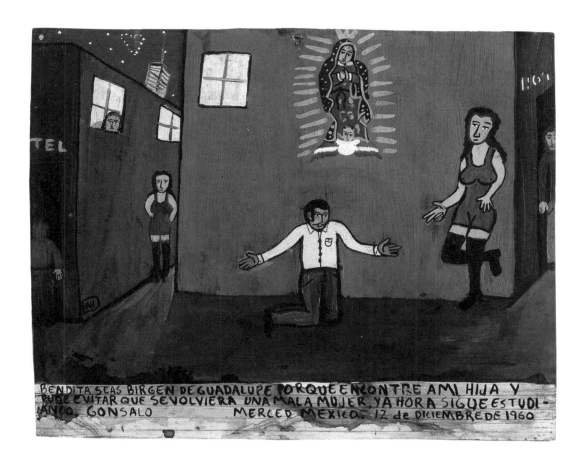

Blessed art thou, Virgin of Guadalupe, because I found my daughter and was able to stop her from becoming a bad woman, and now she has gone back to her schooling. Gonsalo S——. Merced, Mexico. December 12, 1960.

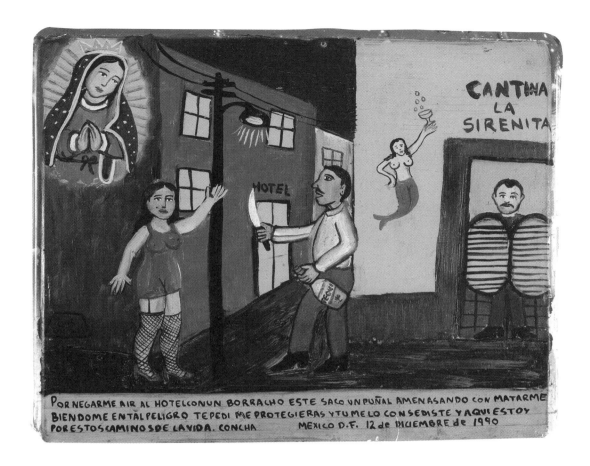

PORNEGARME AIR AL HOTELCONUN BORRACHO ESTE SACO UNPUÑAL AMENASANDO CON MATARME BIENDOME ENTALPELIGRO TEPEDI ME PROTEGIERAS YTUMELO CONSEDISTE YAQUIESTOY PORESTOSCAMINOSDE LAVIDA. CONCHA MEXICO D.F. 12 de DICIEMBRE de 1990

When I refused to go to a hotel with a drunk, he pulled out a knife and threatened to kill me. In this moment of danger I prayed to you for protection and you granted it to me, and here I am in this walk of life. Concha M——. Mexico D.F. December 12, 1990.

[On building:] Little Mermaid Cantina

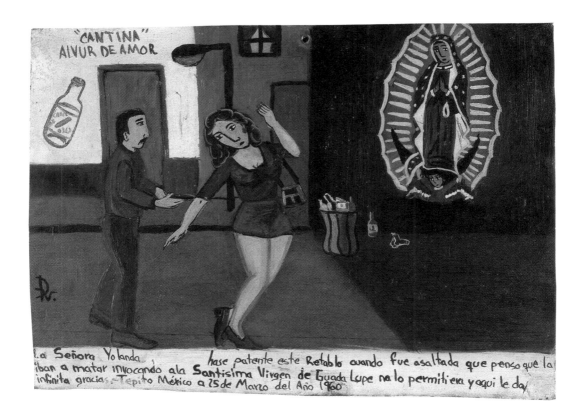

Señora Yolanda D—— bears witness with this retablo that when she was attacked she thought they were going to kill her and appealed to the Most Holy Virgin of Guadalupe not to allow it, and now she gives infinite thanks. Tepito, Mexico. March 25, 1960.

[On building:] Risks of Love Cantina

I am having this retablo made for San Juan Diego as I promised, for my first time, which I will never forget, at the age of 17. I learned to use a condom to protect myself from infection and have a good time, with a prostitute who looked so great I couldn't resist the urge to go to the hotel with her. This took place in Suliván, Mexico D.F. Friday, August 16, 2002.

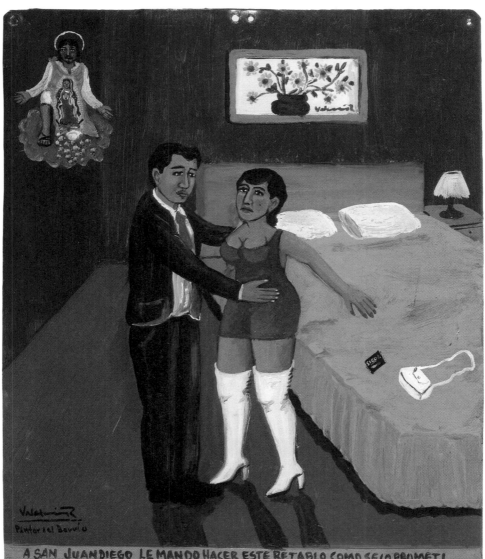

A SAN JUANDIEGO LE MANDO HACER ESTE RETABLO COMO SE LO PROMETI
ESTA MI PRIMERA VES QUE NUNCA OLVIDARE ALA EDAD DE 17 AÑOS APRENDI A.
USAR CONDON PARA PROTEJERME DE UNA INFECCION Y PASAR UN BUEN RATO CON
UNA PROSTITUTA QUE AL BERLA TAN BUENOTA NO ME PUDE AGUANTAR LAS GANAS
DE LLEVARLA AL HOTEL ACONTECIO EN SULIVAN MEXICO DF. VIERNES 16 AGOSTO. 2002
———— A.P.M. ————

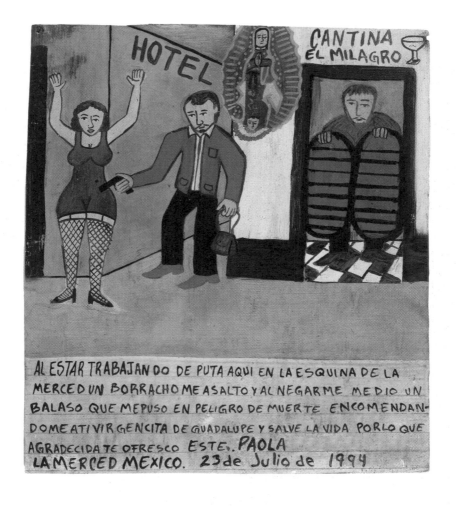

AL ESTAR TRABAJANDO DE PUTA AQUI EN LA ESQUINA DE LA
MERCED UN BORRACHO ME ASALTO Y AL NEGARME MEDIO UN
BALASO QUE ME PUSO EN PELIGRO DE MUERTE ENCOMENDAN-
DOME A TI VIRGENCITA DE GUADALUPE Y SALVE LA VIDA POR LO QUE
AGRADECIDA TE OFRESCO ESTE. PAOLA
LA MERCED MEXICO. 23 de Julio de 1994

When I was working as a prostitute on the corner in La Merced a drunk grabbed me and when I refused him he shot me and I was in danger of dying. I entrusted myself to you, Virgin of Guadalupe, and my life was saved, for which I offer you this in gratitude. Paola F——. La Merced, Mexico. July 23, 1994.

[On building:] Miracle Cantina

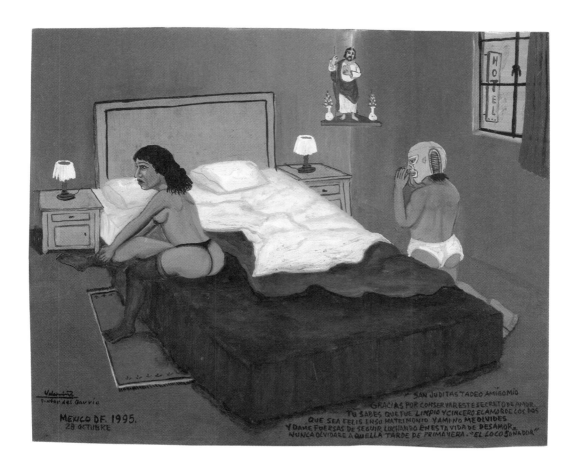

San Judás Tadeo, my friend, thank you for keeping this lovers' secret. You know that our love was clean and honest for both of us. May she be happy in her marriage. Do not forget me, and give me strength to fight on in this loveless life. I will never forget that springtime afternoon. "Crazy Dreamer." Mexico D.F. 1995. October 28.

Refugio S——. 1984. I was deceived by the man I loved most, who forced me to sell myself in the street. I give thanks to the Holy Infant that my parents forgave me and today I am going back to Zacatecas, which I never should have left.

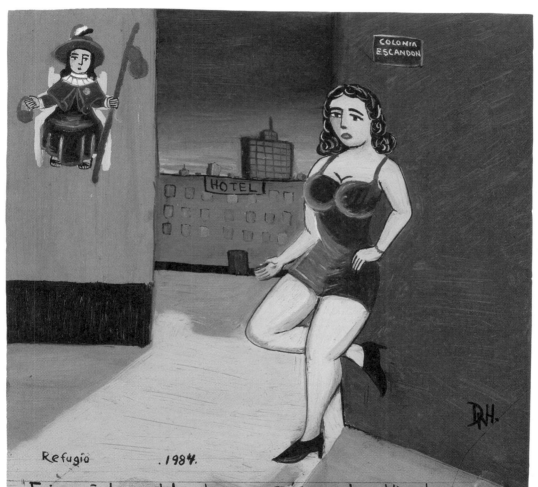

Refugio . 1984.

Fui engañada por el hombre que más amaba obligandome a venderme aqui en la calle doy gracias a Santo Niño que mis padres me perdonaron hoy regreso a Zacatecas de donde nunca ubiera salido

THE CIRCUS

On April 30, 1980, a ferocious lion leaped at me, and in this danger I called upon the Sweet Virgin of Guadalupe and was able to get the lion under control without getting hurt. My act came out very well. Seferino M——. Atayde Brothers Circus, Mexico tour.

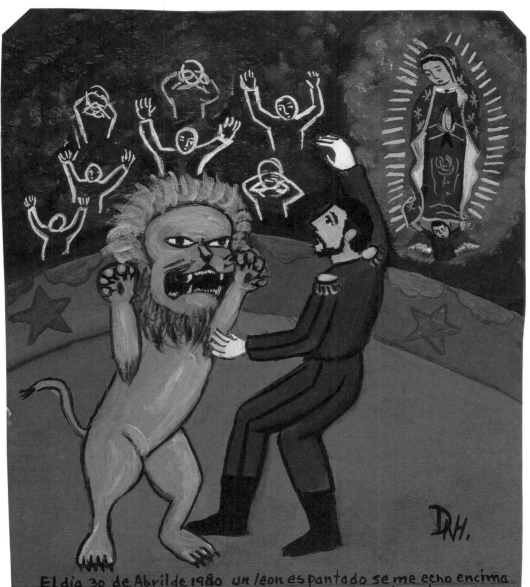

El dia 30 de Abril de 1980 un leon espantado se me echo encima
Biendo el peligro invoque a la virgencita de Guadalupe logrando
someterlo sin causarme daño alguno. miacto salio muy bien.
Seferino ocurrio en el circo Atayde. en la tenporada en Mexico.

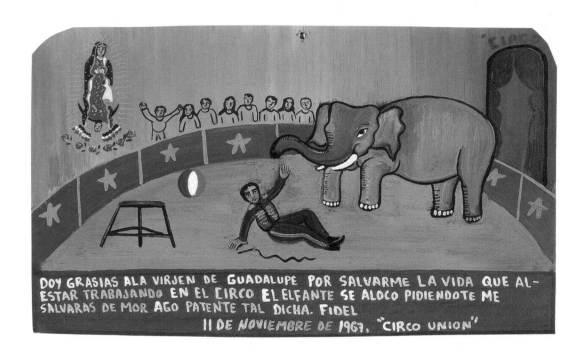

I give thanks to the Virgin of Guadalupe for saving my life. I was working in the circus when an elephant went crazy. I prayed to you to save me from death, and I bear witness to your grace. Fidel M——. November 11, 1967. Unión Circus.

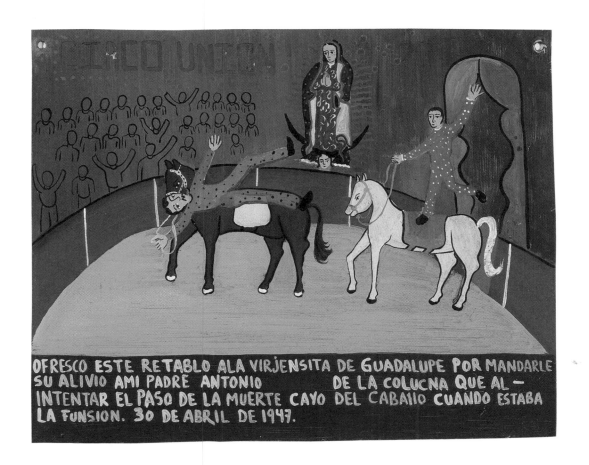

OFRESCO ESTE RETABLO ALA VIRJENSITA DE GUADALUPE POR MANDARLE SU ALIVIO AMI PADRE ANTONIO DE LA COLUCNA QUE AL – INTENTAR EL PASO DE LA MUERTE CAYO DEL CABAИO CUANDO ESTABA LA FUNSION. 30 DE ABRIL DE 1947.

I offer this retablo to the Blessed Virgin of Guadalupe for healing the spine of my father, Antonio, who in trying to perform the Leap of Death fell off his horse during the show. April 30, 1947.

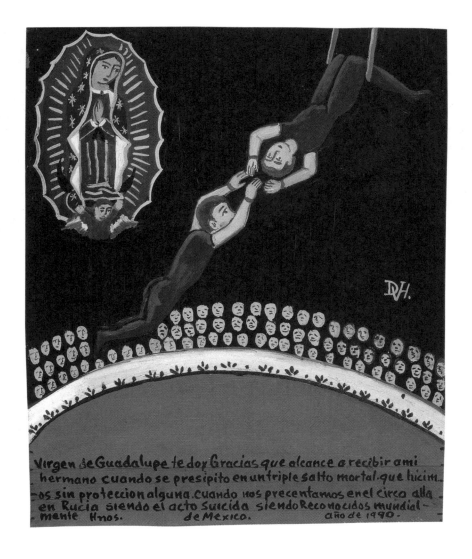

Virgin of Guadalupe, I give you thanks that I was able to catch my brother when he did the triple somersault of death, which he performed with no protection when we appeared in the circus in Russia as the Suicide Act, as we are known worldwide. R—— Brothers of Mexico. Year 1990.

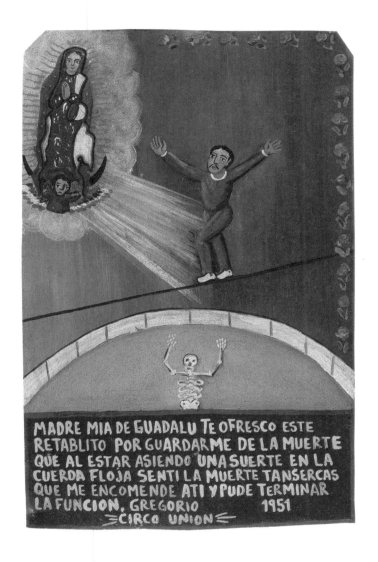

Our Mother of Guadalupe, I offer you this retablo for shielding me from death when I was performing a maneuver on the tightrope and suddenly felt death very near. I entrusted myself to you and was able to finish the show. Gregorio M——. 1951. Unión Circus.

Señor Antonio V—— offers this retablo to the Virgin of Guadalupe for curing his heart problem, so that now he can continue to work as a clown and entertain the children. Coco Verde, the Clown. 1950. Mexico.

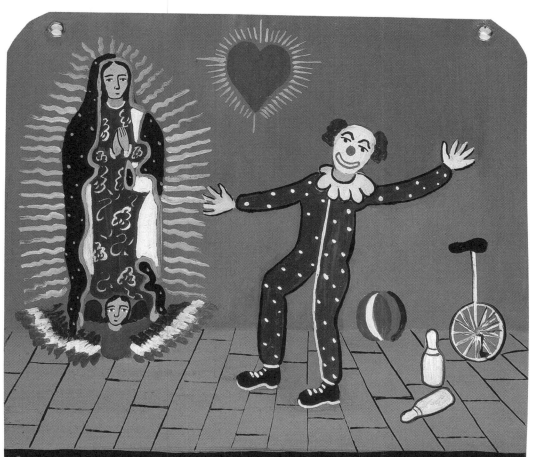

EL SEÑOR ANTONIO OFRESE ESTE
RETABLO ALA VIRJEN DE GUADALUPE POR MANDARLE
SU ALIVIO DE SU CORAZON Y PUEDE SEGUIR TRAVAJANDO
DE PAIIASITO Y DIVIRTIENDO ALOS NIÑOS.
PAIIASITO COCO VERDE 1950 MEXICO

URBAN VIOLENCE

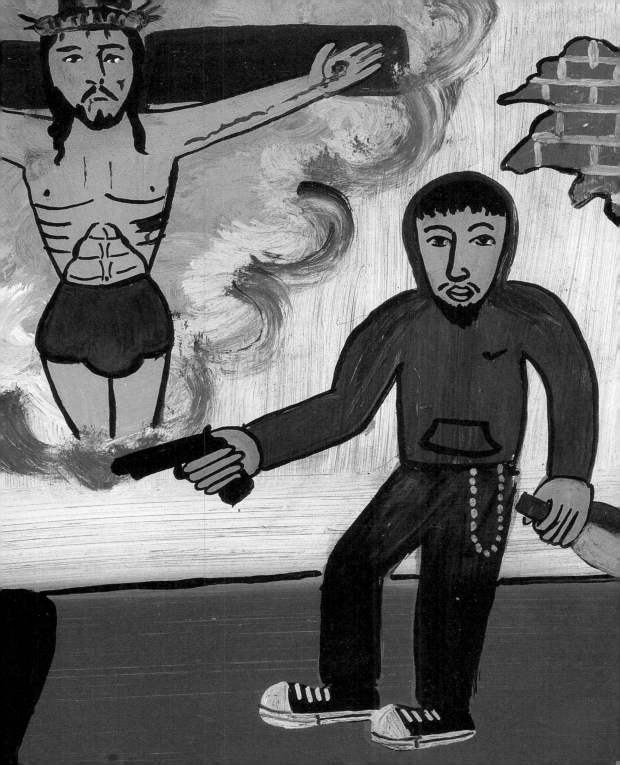

Forgive me, Dear God, for disrespecting my father when I was on drugs and I came home and tried to hit him. When he realized what was happening and scolded me, I understood that I had gone wrong and vowed I would not take drugs again and would listen to his advice. He forgave me and helped me to overcome this terrible vice. Paco M——. Barrio Norte, Mexico. May 10, 2000.

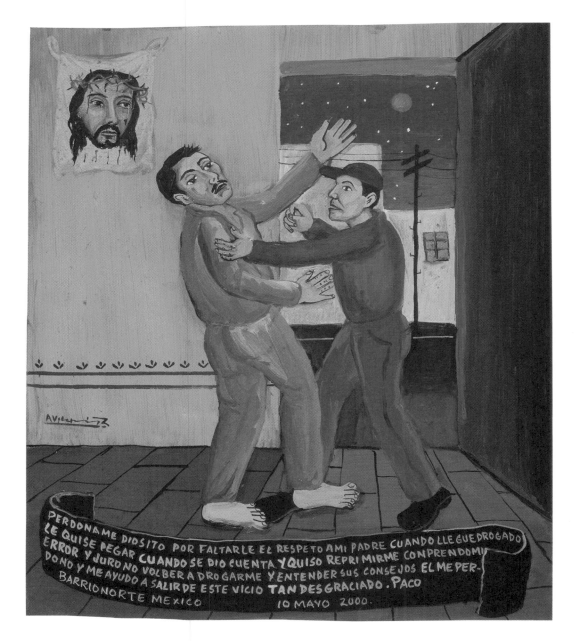

PERDONAME DIOSITO POR FALTARLE EL RESPETO A MI PADRE CUANDO LLEGUE DROGADO LE QUISE PEGAR CUANDO SE DIO CUENTA Y QUISO REPRIMIRME CONPRENDO MI ERROR Y JURO NO VOLBER A DROGARME Y ENTENDER SUS CONSEJOS EL ME PER-DONO Y ME AYUDO A SALIR DE ESTE VICIO TAN DESGRACIADO. PACO BARRIO NORTE MEXICO 10 MAYO 2000.

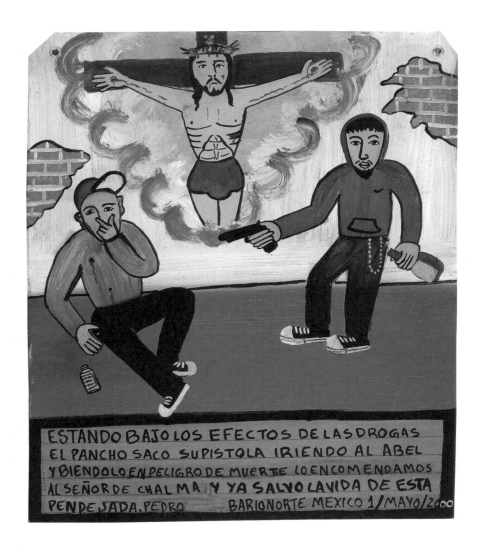

ESTANDO BAJO LOS EFECTOS DE LAS DROGAS
EL PANCHO SACO SU PISTOLA IRIENDO AL ABEL
Y BIENDOLO EN PELIGRO DE MUERTE LO ENCOMENDAMOS
AL SEÑOR DE CHALMA Y YA SALVO LA VIDA DE ESTA
PENDEJADA. PEDRO BARIO NORTE MEXICO 1/MAYO/2000

Under the influence of drugs, Pancho pulled out a pistol and wounded Abel. He was in danger of dying, and we entrusted him to the care of Lord Jesus of Chalma, and his life was saved from this foolish act. Pedro C——. Barrio Norte, Mexico. May 1, 2000.

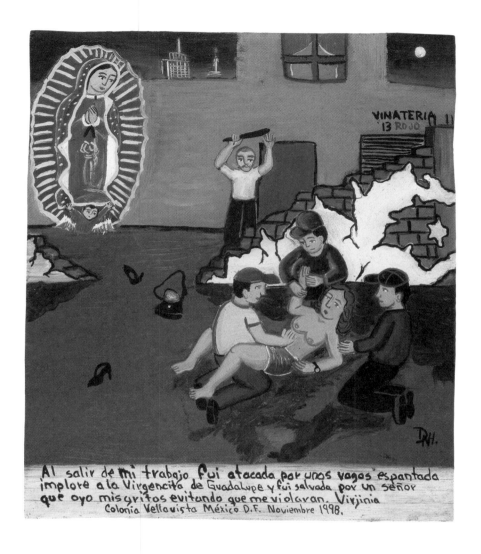

Leaving work, I was attacked by some hoodlums, and in my fear I prayed to the Sweet Virgin of Guadalupe and I was saved by a gentleman who heard my cries, so they did not rape me. Virjinia M——. Colonia Bellavista, Mexico, D.F. November 1998.

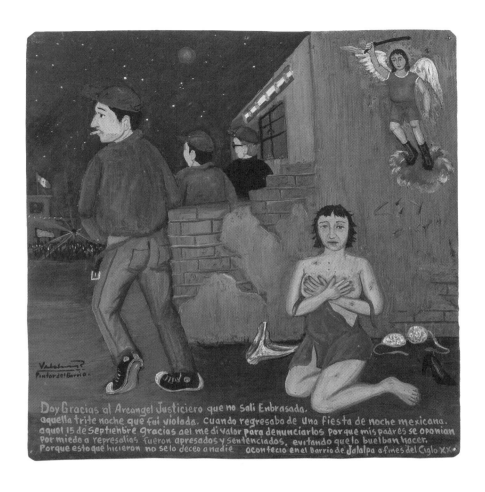

Doy Gracias al Arcangel Justiciero que no Sali Enbrasada.
aquella trite noche que fui violada. Cuando regresaba de una fiesta de noche mexicana.
aquel 15 de Septienbre gracias ael me di valor para denunciarlos por que mis padres se oponian
por miedo a represalias fueron apresados y sentenciados, evitando que lo buelban hacer.
Porque esto que hicieron no se lo deceo a nadie acontecio en el Barrio de Jalalpa a fines del Ciglo XX.

I give thanks to the Archangel of Justice that I did not get pregnant that awful night of September 15 when I was raped on my way home from a party for Mexican Independence Day. Thanks to him, I had the courage to press charges, because my parents were against it for fear of revenge. The attackers were arrested and sentenced, so they won't be able to do it again. Because what they did I don't wish on anyone. This took place in the Jalapa neighborhood at the end of the 20th century.

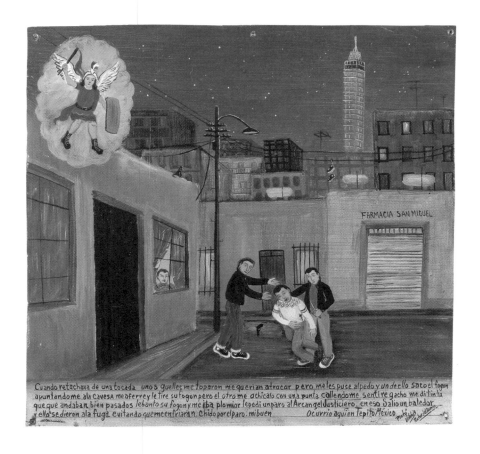

Cuando retachava de una tocada unos guelles me toparon me querian atracar pero me les puse alpedo y un de ello sacoel fogon apuntandome ala cavesa me aferrey le tire su fogon pero el otro me achicalo con una punta callendome sentire gacho me di tinta que que andaban bien pasados lebanto su fogon y me iba plomiar le pedi unparo al Arcangel Justiciero, en eso Dalio un baledor, y ellos se dieron ala fuga evitando que me enfriaran. Chido porelparo. mibuen Ocurrio aqui en Tepito/Mexico.

When I was coming back from a concert some motherfuckers tried to mug me, but I gave them shit and one of them pulled out a gun and pointed it at my head. I grabbed it and threw the gun away, but the other guy shanked me and I thought I'd had it. I knew they were flyin' on drugs. He picked up the gun and was getting ready to plug me. I prayed to the Archangel of Justice to stop him, and just then my buddy showed up and they ran away, so I didn't get iced. Right on for the favor, pal. This took place here in Tepito, Mexico.

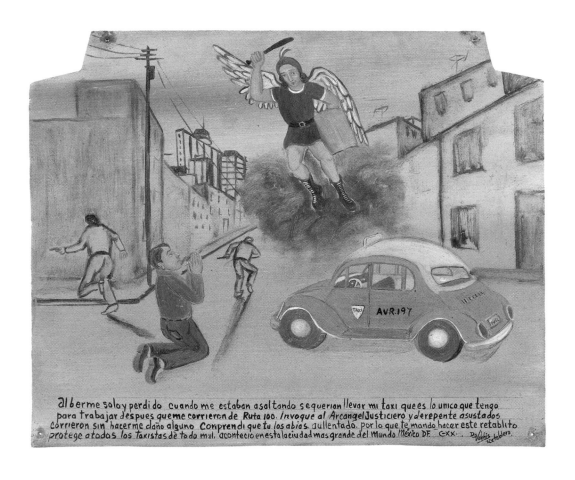

Al berme solo y perdido cuando me estaban asaltando se querian llevar mi taxi que es lo unico que tengo para trabajar despues que me corrieron de Ruta 100. Invoque al Arcangel Justiciero y derepente asustados corrieron sin hacerme daño alguno Comprendi que tu los abias aullentado. por lo que te mando hacer este retablito protege a todos los taxistas de todo mal. acontecio en esta la ciudad mas grande del mundo. México DF. C-XX. Davichis Retablero.

One time when I was by myself and lost, I got attacked. They wanted to steal my taxi, which is all I have since I got kicked out of Ruta 100,* so I called on the Archangel of Justice and suddenly they got scared and ran away without doing anything to me at all. I realized you had chased them off, and for this I am having this retablo made. Shield all cab drivers from all evil. This took place in this, the biggest city in the world. Mexico D.F. 20th century.

*Bus drivers' union in Mexico City

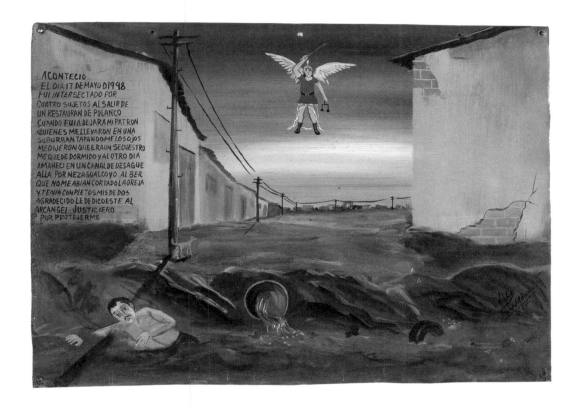

It happened on the 17th day of May, 1998, that I was accosted by four individuals as I left a restaurant in Polanco, where I had dropped off the man I work for. They took me away in a Suburban, blindfolding my eyes, and said it was a kidnap. I went to sleep, and the next day I woke up in a drainage ditch down in Nezahualcóyotl. Finding that they had not cut off my ear and I had all my fingers, I now dedicate this to you in thanks, Archangel of Justice, for protecting me.

I give infinite thanks to the Sweet Virgin of Solitude for healing my son Lorenzo when he was attacked and got shot in the leg. Soledad R——. Together we bring you this retablo. 1929.

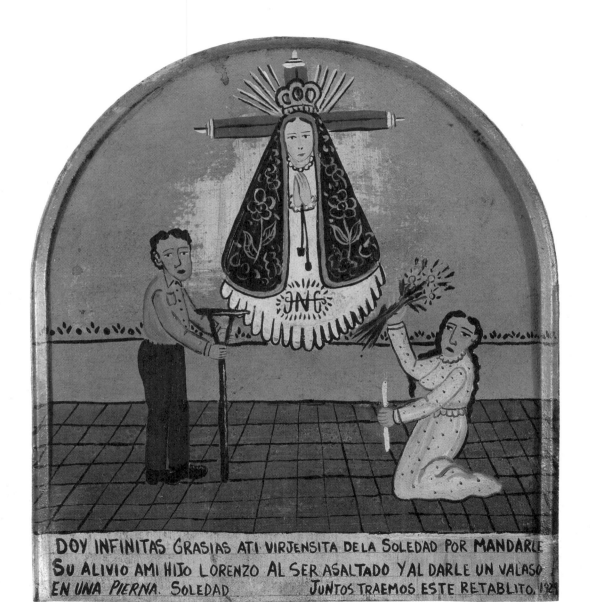

DOY INFINITAS GRASIAS ATI VIRJENSITA DE LA SOLEDAD POR MANDARLE
SU ALIVIO AMI HIJO LORENZO AL SER ASALTADO Y AL DARLE UN VALASO
EN UNA PIERNA. SOLEDAD JUNTOS TRAEMOS ESTE RETABLITO. 192

EMIGRATION

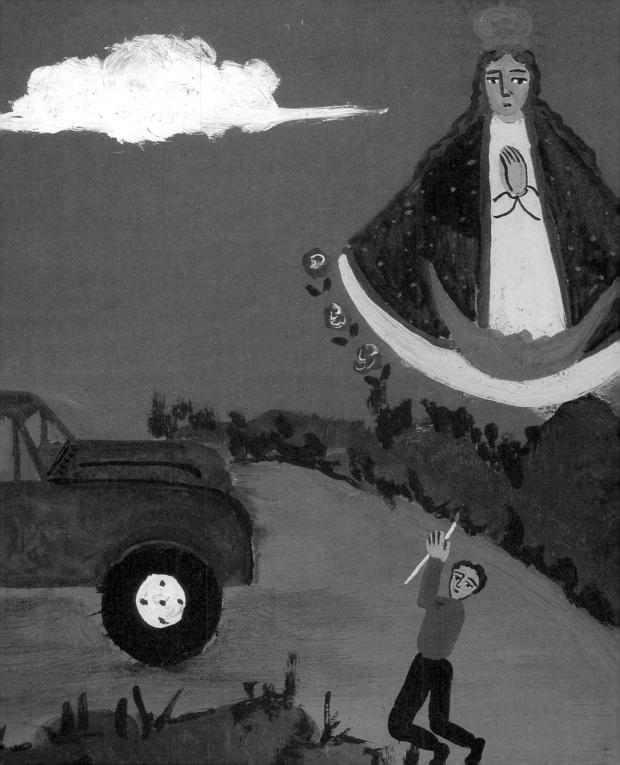

As we do every year, Sacred Lord of Chalma, we come to bring you thanks for granting us the grace to come one more year, and we ask you to shower with blessings my sons, together with their wives and their children, there in the United States. May they never lack for anything and always enjoy good health. We ask you as two elders who never forget that they too were children once, and when they return, may it not be too late, for we have faith that one day they will return, because it has been five years since we have had any news of them. God bless them wherever they may be. December 31, 1958. Eleuterio T—— and Eufrocina C——. San Bártolo Ameyalco, Mexico.

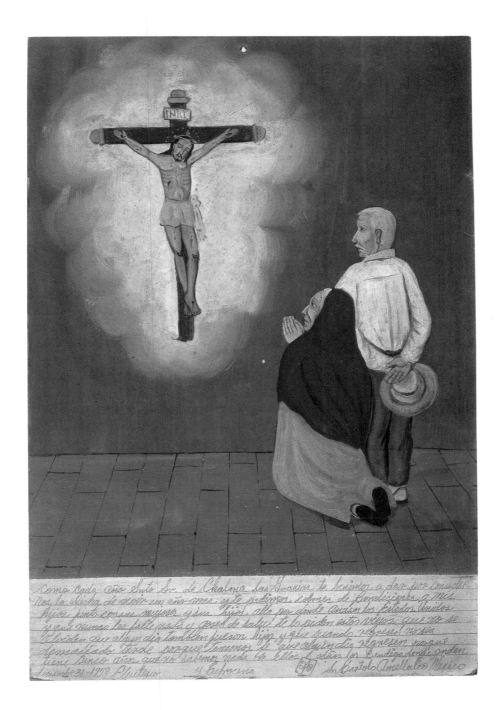

Como cada Año Snto Sr. de Chalma las Gracias te benimos a dar por conseder-
nos la dicha de vivir un año mas, y te pedimos, colmes de Bendiciones, a mis
hijos junto con sus mujeres y sus hijos, alla por donde Andan los Estados Unidos
y que nunca les falte nada y gozen de Salud, te la piden estos viejos, que no se
olviden que algun dia tambien fueron hijos, y que cuando regresen no sea
demaciado tarde porque tenemos, fe que algun dia regresen porque
tiene Cinco años que no sabemos nada de ellos, Dios los bendiga donde anden
Diciembre 31 1958 Plenitique y Eutrocina Sn Bartolo Amellalco Mejico

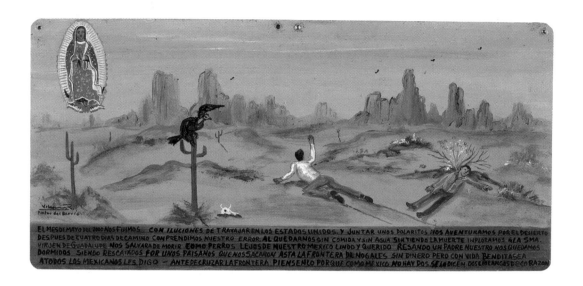

In 2000, in the month of May, we set off through the desert with dreams of working in the United States to put aside a few dollars. After four days of walking we realized our mistake when we found ourselves without food or water. Sensing death near, we prayed to the Most Holy Virgin of Guadalupe to save us from dying like dogs, far from our beautiful, beloved Mexico. Saying an Our Father, we went to sleep. We were rescued by some countrymen who took us as far as Nogales, on the border, with no money but with our lives. Blessed art thou. To all Mexicans I say, think about it before you cross the border, because there is no place like Mexico. Two true *chilangos** are here to tell you.

* Slang for residents of Mexico City

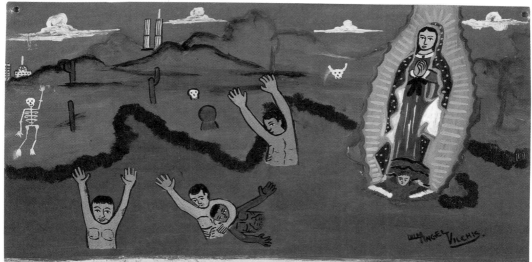

Birgencita de Guadalupe las gracias te doy por darme fuersas de salvar a mi hermana cuando crusamos el rio bravo para ir alos Estados Unidos en busca de trabajo logramos llegar ynos fue muy bien y amparados etu bendicion regresamos conbien. Jose y Pedro Puebla Puebla. 10 de Febrero de 1983.

Sweet Virgin of Guadalupe, my thanks to you for giving me the strength to save my brother when we were crossing the Río Bravo* to go to the United States in search of work. We managed to get there and things went well, and thanks to your blessing we returned safely. José and Pedro L——. Puebla, Puebla. February 10, 1983.

* Known in English as the Rio Grande

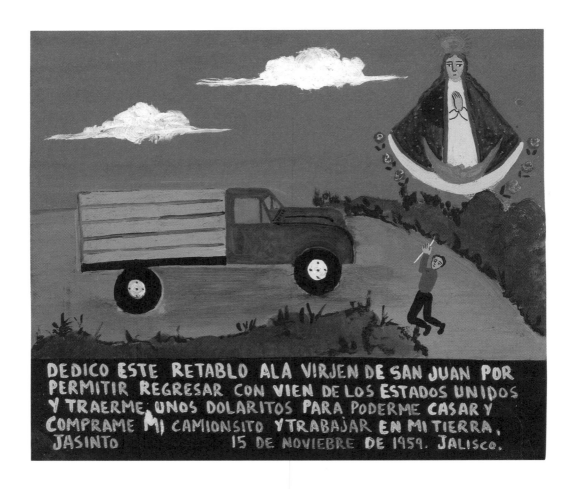

DEDICO ESTE RETABLO A LA VIRJEN DE SAN JUAN POR PERMITIR REGRESAR CON VIEN DE LOS ESTADOS UNIDOS Y TRAERME UNOS DOLARITOS PARA PODERME CASAR Y COMPRAME MI CAMIONSITO Y TRABAJAR EN MI TIERRA, JASINTO 15 DE NOVIEBRE DE 1959. JALISCo.

I dedicate this retablo to the Virgin of San Juan for allowing me to return safely from the United States with a few dollars so I could get married and buy myself a truck and work my land. Jasinto H——. November 15, 1959. Jalisco.

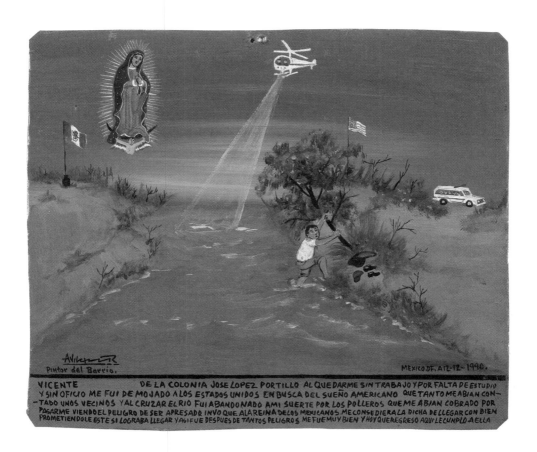

VICENTE DE LA COLONIA JOSE LOPEZ PORTILLO AL QUEDARME SIN TRABAJO Y POR FALTA DE ESTUDIO Y SIN OFICIO ME FUI DE MOJADO A LOS ESTADOS UNIDOS EN BUSCA DEL SUEÑO AMERICANO QUE TANTO ME ABIAN CON- -TADO UNOS VECINOS Y AL CRUZAR EL RIO FUI ABANDONADO A MI SUERTE POR LOS POLLEROS QUE ME ABIAN COBRADO POR PASARME VIENDOEL PELIGRO DE SER APRESADO INVOQUE ALA REINA DE LOS MEXICANOS ME CONSEDIERA LA DICHA DE LLEGAR CON BIEN PROMETIENDOLE ESTE SI LOGRABA LLEGAR Y ASI FUE DESPUES DE TANTOS PELIGROS ME FUE MUY BIEN Y HOY QUE REGRESO AQUI LE CUNPLO A ELLA

Vicente C—— from Colonia José López Portillo, finding myself out of work for lack of schooling or without a trade, went to the United States as a wetback in search of the American Dream my neighbors had talked about so much, and while crossing the river I was abandoned to my fate by the *polleros** who had taken my money to get me across. In danger of being captured, I called upon the Queen of Mexicans to grant me the good fortune to arrive safely, promising her this if I managed to get there, and I did. After running so many risks, it worked out very well, and now that I've come back I am fulfilling my vow to her. Mexico D.F. December 12, 1990.

*Smugglers of illegal immigrants

MEXICAN HISTORY

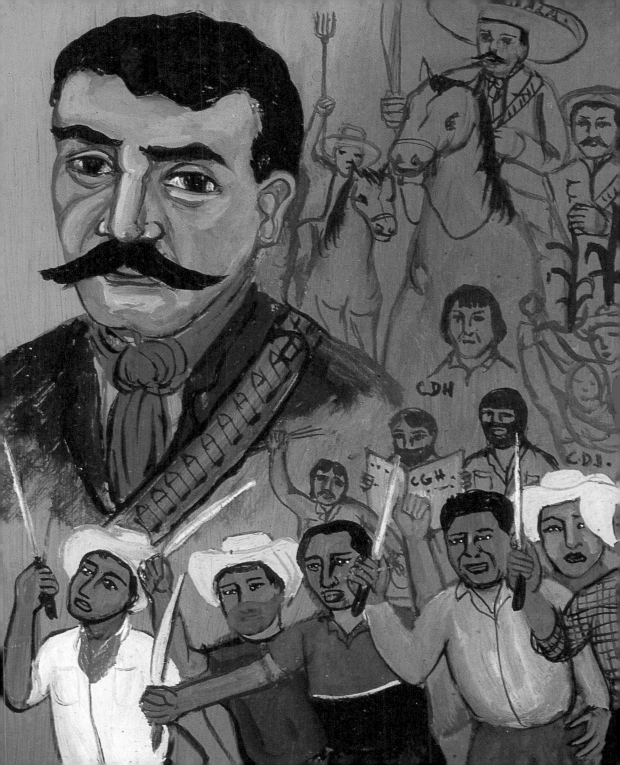

With machete in hand we rise up in struggle to defend our land, rejecting the construction of the airport by means of a ridiculous expropriation. We know we are not alone, and with the blessing of the Most Holy Mary of Guadalupe we will win, showing them that we will never stand by with our arms crossed, and will defend [our land] with our lives if necessary. The people united, in San Salvador Atenco, State of Mexico. August 9, 2002.

[On banner:] People's Defense Committee in Support of the Atenco Struggle. No to the Airport.

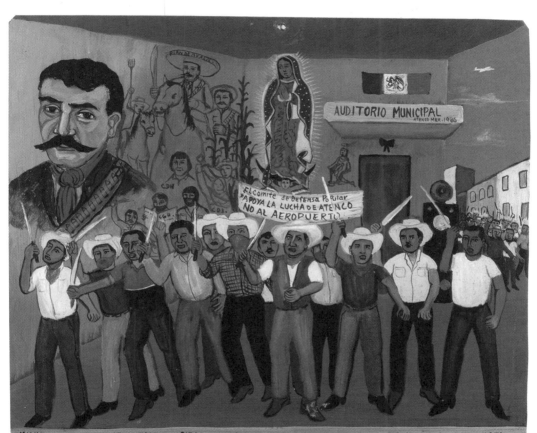

MACHETE EN MANO NOS LEVANTAMOS EN PIE DE LUCHA POR DEFENDER NUESTRAS TIERRAS RECHASANDO LA CONSTRUCION DEL AEROPUERTO CON UNA RIDICULA EXPROPIACION SABEMOS QUE NO ESTAMOS SOLOS Y CON LA BENDICION DE MÃSMA. DE GUADALUPE. LO LOGRAMOS HACIENDOLES SABER QUE NUNCA NOS QUEDAREMOS CON LOS BRAZOS CRUZADO Y LAS DEFENDEREMOS CON NUESTRAS. VIDAS SI ES NESESARIO. PUEBLO UNIDO DE SAN SALVADOR ATENCO. estado de MEXICO 1-AGOSTO-2002 Pinto Valencia

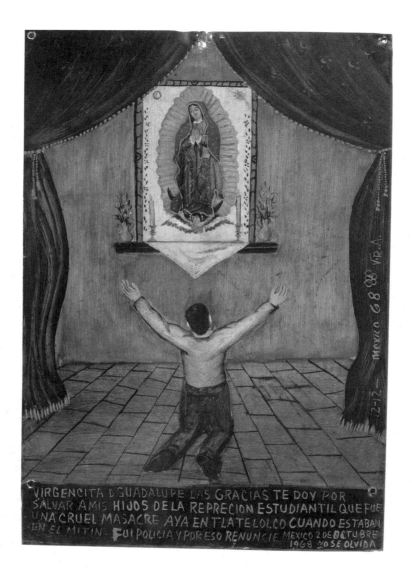

Sweet Virgin of Guadalupe, I give you thanks for saving my children from the student repression that turned into a cruel massacre in Tlatelolco, when they went to the meeting. I was a policeman, and because of this I resigned from the force. Mexico. October 2, 1968. Never forget.

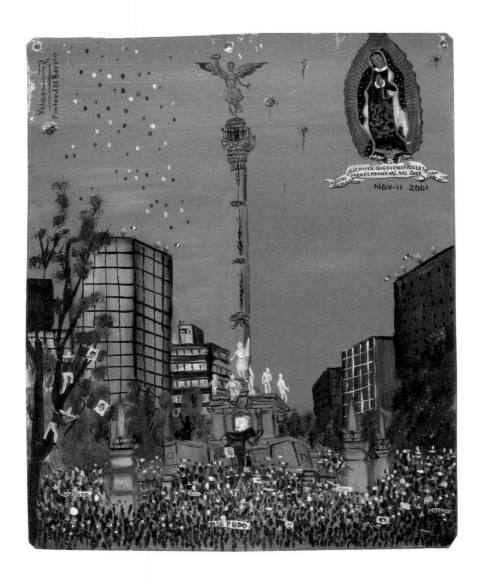

Thank you, Sweet Virgin, that Mexico qualified for the World Cup of 2002. With thanks.
Nov. 11, 2001.

HOMOSEXUALITY

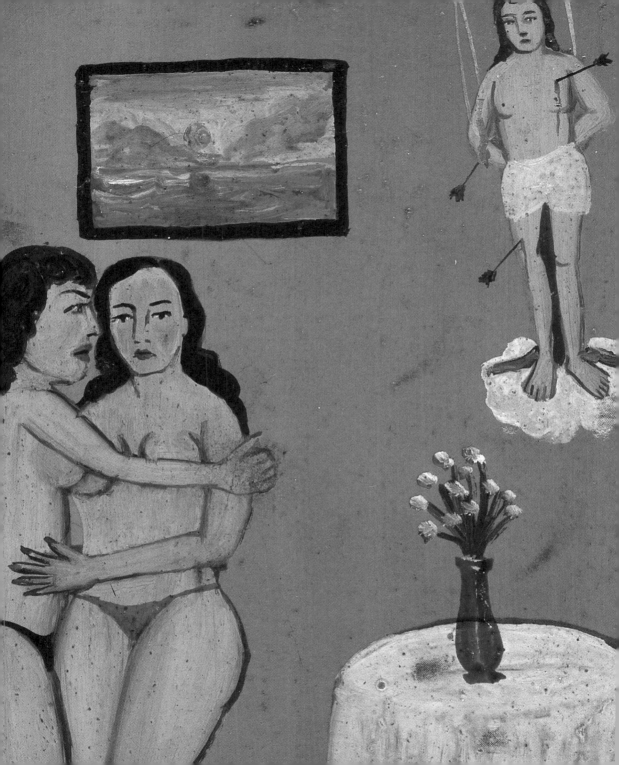

Blessed art thou, Sweet Virgin of Guadalupe, for working a great miracle for me. Luis has come to live with me, because we love each other even though his family doesn't accept our relationship, because it's not our fault that we are the way we are. Luis and Jilverto. Feb. 14, 1985.

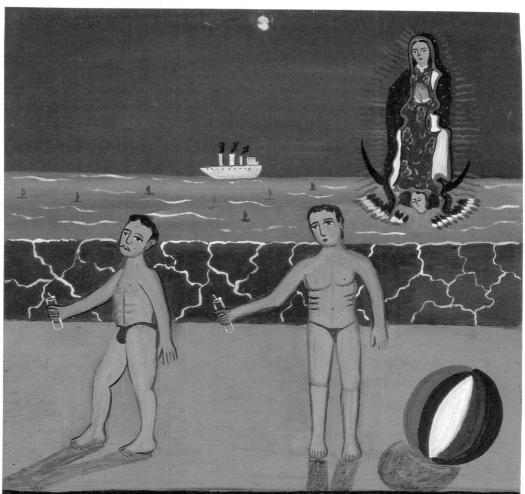

BENDITA SEAS VIRJENSITA DE GUADALUPE POR
ASERME EL MILAGRITO DE QUE LUIS SE VINO A-
VIVIR CON MIGO PUES NOS QUEREMOS AUNQUE
SU FAMILIA NO ASEPTE NUESTRA RELASION PORQUE
NOTENEMOS LA CULPA DE SER COMO SOMOS
ACAPULCO. LUIS Y JILVERTO. 14 DE FEB. DE 1988

Blessed art thou, San Sebastián, because Marta came to live with me and now we are very happy, because we love each other and it's not our fault that we are the way we are. Marta and Luisa. Tacubaya. 1987.

When he got home, Pablo found me chatting with some neighbors. He got very mad and beat me with his belt, but what hurt the most was that he thought I was running around, and he was yelling all kinds of things that weren't true and threatening to leave me. I give thanks to the Virgin that he didn't leave, and we're very happy now. Your most faithful servant, R.C.R. F——. Mexico D.F. 1970.

San Sebastián, I give you thanks because my father finally understood and accepted my homosexuality, allowing me to live my life and giving me his blessing. I understand him too, because I am his only son, but it's not my fault that I was born this way. It's my fate, and there's nothing I can do about it. Ricardo del V——. Polanco, Mexico D.F. June 7, 1980.

I give thanks to the Holy Infant of Atocha that Rober came to live at my apartment, because I was in misery not knowing where he was and who he was with. I dedicate this to you with joy on my lips and happiness in my eyes. Zona Rosa, Mexico. June 17, 1968.

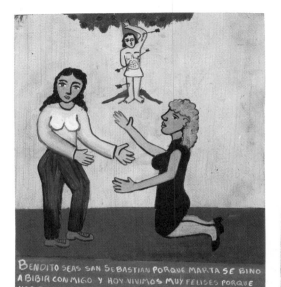

BENDITO SEAS SAN SEBASTIAN PORQUE MARTA SE BINO A BIBIR CONMIGO Y HOY VIVIMOS MUY FELISES PORQUE NOS QUEREMOS Y NO TENEMOS LA CULPA DE SER COMO SOMOS. MARTA Y LUISA. TACUBAYA 1987.

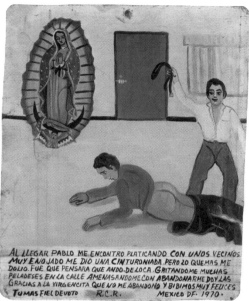

AL LLEGAR PABLO ME ENCONTRO PLATICANDO CON UNOS VECINOS MUY ENOJADO ME DIO UNA CINTURONIADA, PERO LO QUEMAS ME DOLIO. FUE QUE PENSARA QUE ANDO DE LOCA. GRITANDOME MUCHAS PELADESES EN LA CALLE AMENASANDOME CON ABANDONARME DOY LAS GRACIAS A LA VIRGENCITA QUE NO ME ABANDONO Y BIBIMOS MUY FELICES TUMAS FIEL DEVOTO R.C.R. MEXICO DF. 1970.

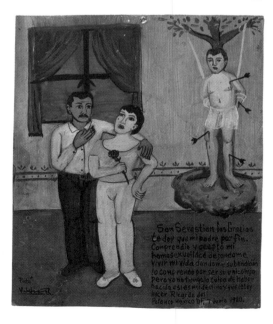

San Sevastian las Gracias te doy que mi madre por fin. Conprendio y acepto mi homosexualidad dandome vivir mi vida dandome subendicion lo conprendio por ser su unico hijo pero yo no tengo la culpa de haber nacida asi es mi destino y que le boy ascer. Ricardo del Palanco Mexico DF. 7 Junio 1980.

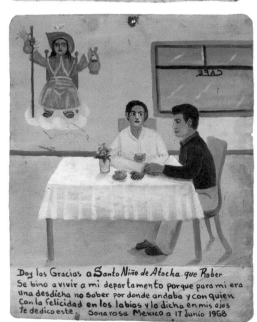

Doy las Gracias a Santo Niño de Atocha, que Rober Se bino a vivir a mi departamento porque para mi era una desdicha no saber por donde andaba y con quien Con la felicidad en los labios y la dicha en mis ojos te dedico este. Sona rosa Mexico a 17 Junio 1968

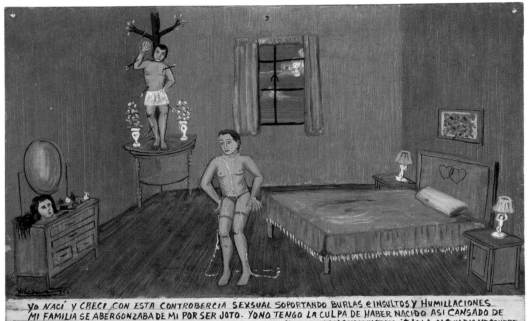

Yo NACI Y CRECI CON ESTA CONTROBERCIA SEXSUAL SOPORTANDO BURLAS e INSULTOS Y HUMILLACIONES. MI FAMILIA SE ABERGONZABA DE MI POR SER JOTO. YO NO TENGO LA CULPA DE HABER NACIDO ASI CANSADO DE TANTO REPROCHE ME FUI DE MI CASA ESTUDIE Y LUCHE CONTRA TODO. HICE MI VIDA Y SOY MUY FELIS. OJALA ALGUN DIA ME CONPRE- -NDAN. Y A SAN SEVASTIAN DOY GRACIAS QUE SALI CON BIEN DE ESTA OPERACION QUE CANBIO MI VIDA. J.A.P. "NOEMY" MEXICO D.F. 14. FEB. 2000

I was born and raised with this sexual controversy, enduring jeering and insults and humil-iations. My family was ashamed of me for being queer. It's not my fault I was born this way. Tired of all the scolding, I left home, I studied, and I fought it all off. I made my life and I am very happy. May it be God's will that they understand me someday, and I give thanks to San Sebastián because I came safely through the operation that changed my life. J.A.P. "Noémy." Mexico D.F. Feb. 2000.

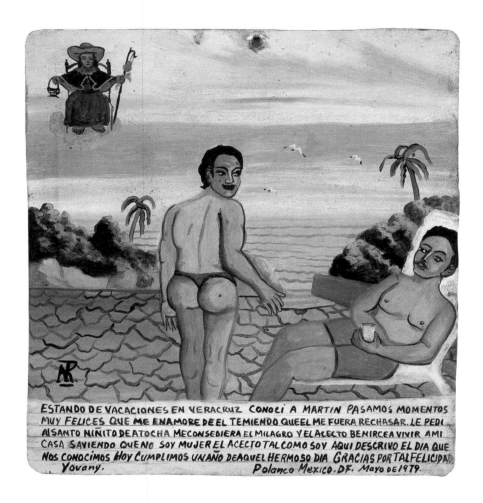

ESTANDO DE VACACIONES EN VERACRUZ CONOCI A MARTIN PASAMOS MOMENTOS
MUY FELICES QUE ME ENAMORE DE EL TEMIENDO QUE EL ME FUERA RECHASAR. LE PEDI
AL SANTO NIÑITO DE ATOCHA ME CONSEDIERA EL MILAGRO Y EL ALECTO BENIRCE A VIVIR A MI
CASA SAVIENDO QUE NO SOY MUJER EL ACECTO TAL COMO SOY AQUI DESCRIVO EL DIA QUE
NOS CONOCIMOS HOY CUMPLIMOS UN AÑO DE AQUEL HERMOSO DIA GRACIAS POR TAL FELICIDAD
Yovany. Polanco Mexico. DF. Mayo de 1979.

When I was on vacation in Veracruz I met Martín, and we had such a good time together
I fell in love with him, but I was afraid he'd reject me. I prayed to the Holy Infant of Atocha
for a miracle, and he agreed to come live at my house, knowing that I'm not a woman.
He accepted me as I am. This shows the day we met. Today it's been a year since that won-
derful day. Thank you for this happiness. Yovany. A. F——. Polanco, Mexico D.F. May 1979.

San Sebastián, I offer you this retablo because Verónica agreed to come live with me. We are thankful to you for granting us this happiness without having to hide from society to have our relationship. Sylvia M——. Lomas de Chapultepec, Mexico D.F. February 14, 1987.

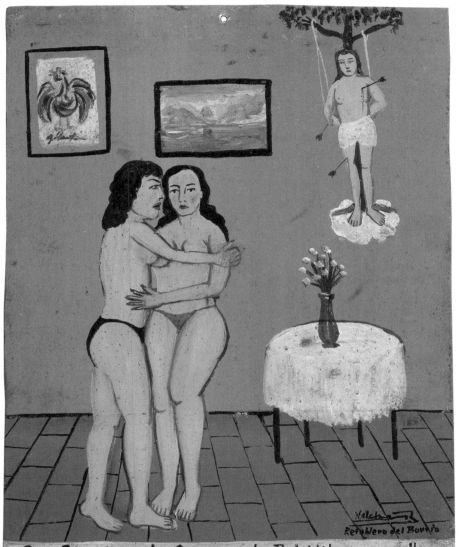

San Sevastion t e Ofresco este Retablito porque lla.
Veronica. acepto Venirse a VIVIR conmigo. te vivimos agradecidas
por concedernos esta felicidad sin tener que ocultarnos de la Sosiedad.
para vivir nuestra Relacion Sylvia.
❀ LOMAS DE CHAPUiTEPEC MEXICO D.F. 14 FEBRERO 1987.

THE WORLD BEYOND

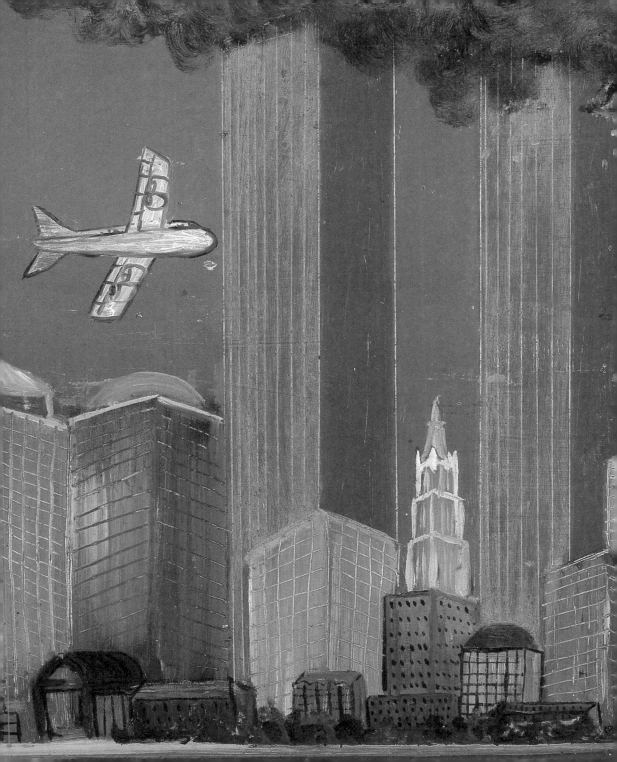

Virgin of Guadalupe, do not let Osama bin Laden attack the United States again, especially not with nuclear weapons, because my relatives are working in Los Angeles, California. Let peace reign, not war, because we are all your children. Bring them to their senses for the sake of humanity. Jesús C——. Mexico D.F. September 30, 2001.

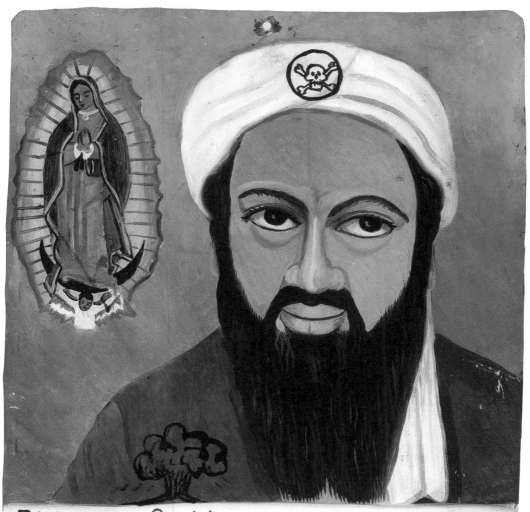

Virjensita de Guadalupe no Permitas que el Señor
Osana vin Laden Buelva atacar a los Estados Unidos
I mucho menos con Atentados nucleares porque alla estan
Trabajando mis familiares en Los Angeles California y que
Reine la PAZ y no la GERRA Porque todos Somos tus hijos
DAles Cordura Por el Bien de la umanidad Jesus
Mexico D,F, 30 de Setienbre del 2001.

I give thanks to the Sweet Virgin of Guadalupe that I was late getting to my job as a waiter at the Hudson River Club restaurant on the second floor of one of the World Trade Center towers. When I came out of the subway and was walking, I heard a very loud cracking sound and saw that twisted pieces of steel were falling, and there were big flames shooting out and huge clouds of smoke. People were running in terror and when I saw that, I ran too. I ran to hide under a bridge, I was choking from the dust but my life was saved, and here I am. Arnulfo C—— R——. In thanks for this miracle granted. Puebla. December 12, 2001.

Thank you, Sweet Virgin of Guadalupe, for granting me the good fortune to return alive to my country to be with my wife and children after the attacks on the twin towers in New York the morning of September 11, 2001. I had come down from the 20th floor to deliver a breakfast of Japanese food when the first one happened and then I could not go back up. Then I saw how the other plane crashed into the other tower. We were evacuated and our lives saved. A thankful Mixtecan, E—— R——. Nov. 30, 2001. Blessed art thou.

I give thanks to the Sweet Virgin of Guadalupe for granting that my life be saved when the first tower fell in New York on September 11 after the terrible attack, when I was working in a crafts shop near the buildings. Pedro R——. Puebla. October 1, 2001.

I, Alfredo Vilchis Roque, neighborhood painter, am saddened to hear about the accident on the space shuttle Columbia, which lifted off January 16 with seven astronauts for the sake of humankind, and today, February 1, 2003, exploded as it was returning to Earth, its debris scattered over the states of Texas and Louisiana. I pray the Virgin of Guadalupe to comfort their families and the people of the United States and Israel, who may be proud of them for serving humanity. From here in Mexico I humbly pay them homage, entrusting their souls to the Most Holy Virgin.

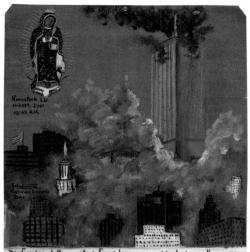

Nueva York E.U.
11-Sept-2001
10:05 A.M.

Pintor del Barrio
2001

Doy Gracias a la Virgencita de Guadalupe que se me hiso tarde para llegar a mi Trabajo de mesero en el Restaurant Hudso River Club. en el segundo piso de una de las Torres del World Trade Center al Salir del metro Camine escuche un crujido muy fuerte y bi que caian pedasos de fierros retorsidos y salia mucha lumbre y arto huma la jenta corria asustada. yo tambien corri a esconderme debajo de un puente Cuando estaba me estaba ogando Por la polvadera pero Salvé la vida y aqui esta Arnulfo Agradeciendo el Milagro Conseidó Puebla, 15 Diciembre 2001

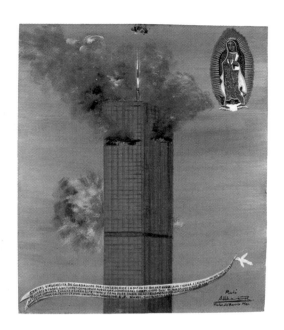

Pintó
A. Vilchis
Pintor del Barrio Mex.

Gracias Virgencita de Guadalupe Por Considerame la Dicha de Salvar la vida a mi Tierra...

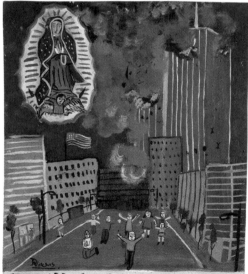

Vilchis

GRASIAS LE DOY A LA VIRJENSITA DE GUADALUPE POR CON-SEDERME LA DICHA DE SALVAR LA VIDA CUANDO SE CAYO LA PRIMERA TORRE DE NUEVA YOR. EL 11 DE SETIEMBRE DESPUES DEL TERRIBLE ATENTADO CUANDO ESTABA TRABAJANDO EN UNA TIENDA DE ARTESANIAS SERCA DE LOS EDIFICIOS PFORD PUEBLA. 1 OCT. 2001

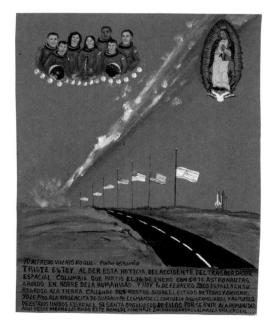

YO ALFREDO VILCHIS ROQUE. Pintor del Barrio
TRISTE ESTOY AL BER ESTA NOTICIA DEL ACCIDENTE DEL TRASBORDADOR ESPACIAL COLUMBIA QUE PARTIO EL 16 DE ENERO CON SIETE ASTRONAUTAS ABORDO EN NOBRE DE LA HUMANIDAD. Y HOY 1. DE FEBRERO 2003 ESTALLA EN SU REGRESO A LA TIERRA CALLENDO SUS RESTOS SOBRE EL ESTADO DE TEXAS Y LUISIANA. YO LE PIDO A LA VIRGENCITA DE GUADALUPE LES MANDE EL CONSUELO A SUS FAMILIARES Y AL PUEBLO DE ESTADOS UNIDOS E ISRRAEL SE SIENTA ORGULLOSOS DE ELLOS. POR SERVIR A LA HUMANIDAD AQUI DESDE MEXICO LES RINDO ESTE HUMILDE HOMENAJE ENCOMENDANDOSE A LA MALAGROSA VIRGEN....

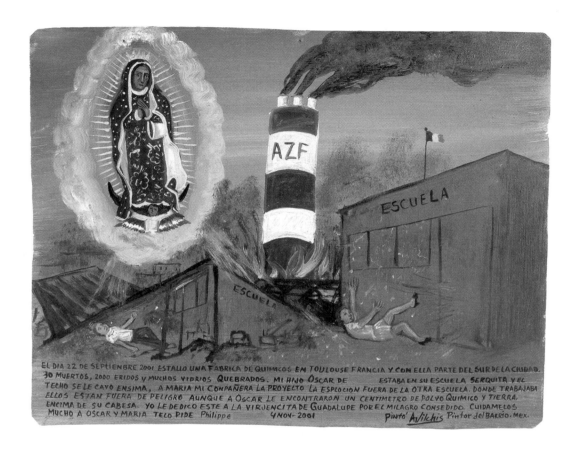

EL DIA 22 DE SEPTIEMBRE 2001 ESTALLO UNA FABRICA DE QUIMICOS EN TOULOUSE FRANCIA Y CON ELLA PARTE DEL SUR DE LA CIUDAD. 30 MUERTOS, 2000 ERIDOS y MUCHOS VIDRIOS QUEBRADOS. MI HIJO OSCAR DE ESTABA EN SU ESCUELA SERQUITA y EL TECHO SE LE CAYO ENSIMA, A MARIA MI CONPAÑERA LA PROYECTO LA ESPLOCION FUERA DE LA OTRA ESCUELA. DONDE TRABAJABA ELLOS ESTAN FUERA DE PELIGRO AUNQUE A OSCAR LE ENCONTRARON UN CENTIMETRO DE POLVO QUIMICO Y TIERRA. ENCIMA DE SU CABEZA. YO LE DEDICO ESTE A LA VIRUENCITA DE GUADALUPE POR EL MILAGRO CONSEDIDO. CUIDAMELOS MUCHO A OSCAR y MARIA TE LO PIDE Philippe 4 NOV-2001 Pinto' Avilchis Pintor del BARRIO. MEX.

On the 22nd day of September 2001, a chemical factory exploded in Toulouse, France, and with it some of the southern part of the city. 30 dead, 2,000 wounded, and lots of broken windows. My son Oscar de S—— was in his school nearby, and the roof caved in on him. María, my girlfriend, got blown out of the building by the explosion, in another school where she was working. They're out of danger now, but they found a centimeter of chemical dust and dirt on Oscar's head. I dedicate this to the Sweet Virgin of Guadalupe for granting this miracle. Take good care of Oscar and María, I pray you. Philippe P——. Nov. 4, 2001.

[On building:] School

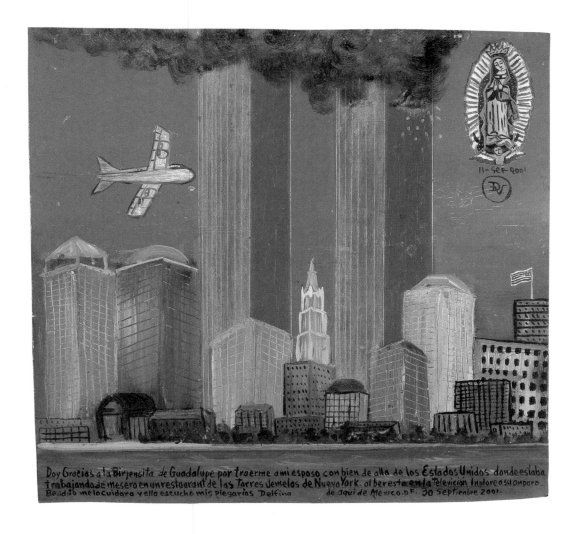

Doy Gracias a la Birjensita de Guadalupe por traerme a mi esposo con bien de alla de los Estados Unidos, donde estaba
trabajando de mesero en un restaurant de las Torres Jemelas de Nueva York. al ber esto en la Televición Imploreasuanparo
Bendito melocuidara y ella escuchó mis plegarias. Delfina de aqui de Mexico.D.F. 30 Septienbre 2001.

I give thanks to the Sweet Virgin of Guadalupe for bringing my husband back to me safely from the United States, where he was working as a waiter in a restaurant in the Twin Towers in New York. When I saw this on television I begged her to watch over him with her divine aid, and she heard my prayers. Delfina A——, from here in Mexico D.F. September 30, 2001.

SPORTS

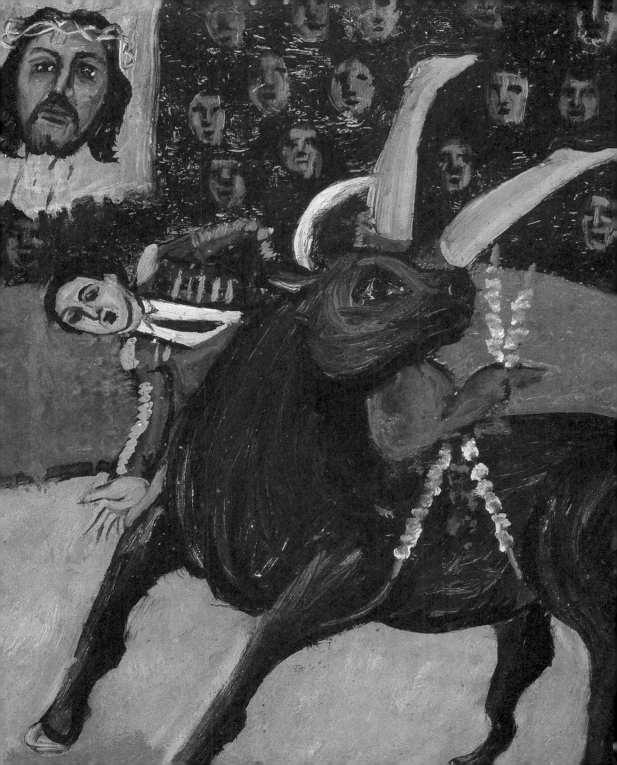

My infinite thanks to the Virgin of Guadalupe that my arm is better now after El Santo* put me in this armlock, twisting it so that for three months I could not move my arm. I appealed for your aid, and now I can move it fine and I'm wrestling again. Enrique L——. Mexico. 1969.

*A famous Mexican wrestler, known as The Saint

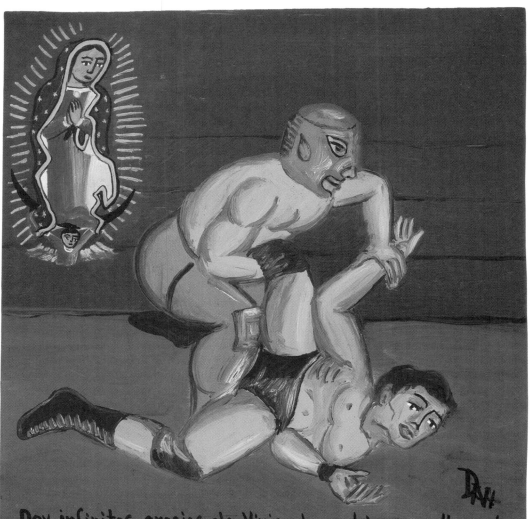

Doy infinitas grasias ala Virjen de guadalupe que lla quede
bueno de mi braso despues que el Santo me iso esta llave
torsiendome el braso y sin poderlo mover 3 meses aclame a tu
anparo y ya pudo moberlo bien y buelvo a luchar.
 Enrique Mexico 1969.

Juanito C——, age 14, gives thanks to the Virgin that Blue Demon didn't give up and won the fight against La Parca,* because he gave me the wheelchair he had promised me, because I have bad feet and can't walk. Take good care of him, because he is my idol and he is good people.

* Wrestler's name is slang for Death

El Santo* in a silver mask was losing because of a bad landing, and with this fantastic head-butt he won the welterweight championship from Peter Pancoff. And now he gives thanks to the Sweet Virgin of Guadalupe for becoming the first world champion from Mexico in the year 1943.

* The Saint

Thank you, Sweet Virgin of Guadalupe, that with this fantastic head-butt in the Christ position El Santo beat El Diavólico, winning his mask, and was safe and sound after this dangerous, spectacular move that had never been seen before in wrestling. When I witnessed it I entrusted him to you, and I pray you to protect him because he is the people's idol. Señor Pedro D—— C——. Mexico. 1975.

Thanks be to God that César R—— has healed from his wound after he was gored on a pass by Fujitivo* during the ninth corrida at the bullfights in Seville, Spain, on April 29. I entrusted him to your care, because he's a bullfighter with lots of guts and he's my favorite. May he soon return to bullfight here in the Plaza de Mexico and may God protect him. Carmelita A——. Mexico. 1993.

* Bull's name means "Runaway"

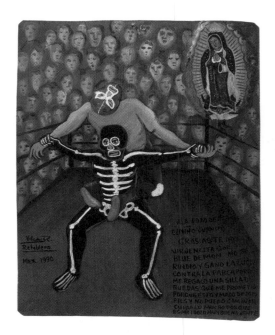

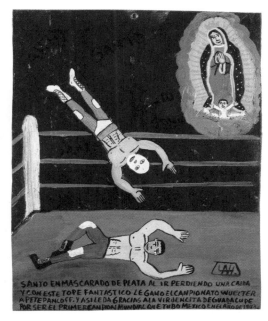

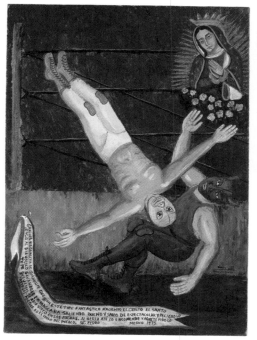

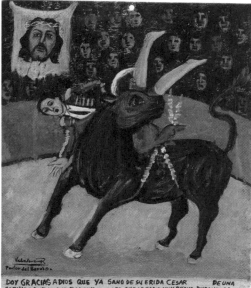

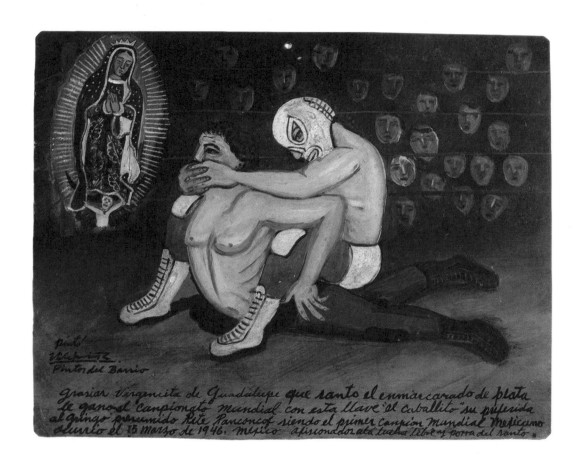

Thank you, Sweet Virgin of Guadalupe, that El Santo "the Silver Mask" won the world championship with this lock, "the hobbyhorse," his favorite, from that conceited gringo Peter Pancoff, becoming the first world champion from Mexico. This took place March 15, 1946. Mexico. El Santo fan club, lovers of *lucha libre*.*

* Mexican wrestling

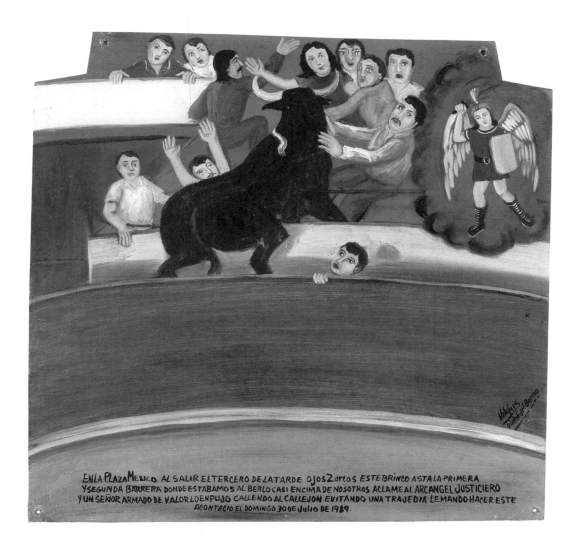

EN LA PLAZA México AL SALIR EL TERCERO DE LA TARDE OJOS Zarcos ESTE BRINCO ASTA LA PRIMERA Y SEGUNDA BARRERA DONDE ESTABAMOS AL BERLO CASI ENCIMA DE NOSOTROS ACLAME AL ARCANGEL JUSTICIERO Y UN SEÑOR ARMADO DE VALOR LO EN PUJO CALLENDO AL CALLEJON EVITANDO UNA TRAJEDIA LE MANDO HACER ESTE ACONTECIO EL DOMINGO 30 DE Julio DE 1989.

In the third bullfight of the afternoon at Plaza México, when Ojos Zarcos* was released, he jumped over the first and second fence right where we were. Seeing him nearly on top of us, I appealed to the Archangel of Justice, and a brave man pushed him so he fell back into the walkway, and tragedy was averted. I have had this made for [the Archangel]. This took place on Sunday, July 30, 1989.

* "Light Blue Eyes"

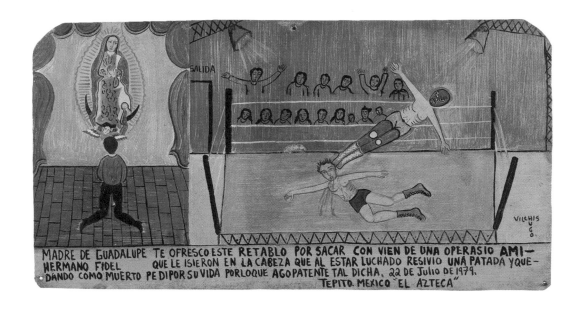

Our Mother of Guadalupe, I offer you this retablo for watching over my brother Fidel C—— during an operation on his head after he was stomped while wrestling and fell down as though dead. I prayed for his life, and I bear witness to this good fortune. July 22, 1979. Tepito, Mexico. "El Azteca."*

* "The Aztec"

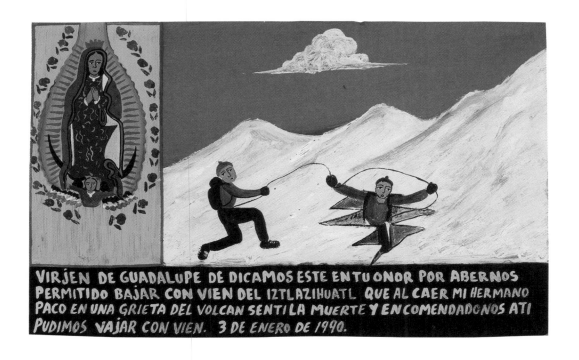

VIRJEN DE GUADALUPE DE DICAMOS ESTE EN TU ONOR POR ABERNOS PERMITIDO BAJAR CON VIEN DEL IZTLAZIHUATL QUE AL CAER MI HERMANO PACO EN UNA GRIETA DEL VOLCAN SENTI LA MUERTE Y ENCOMENDADONOS ATI PUDIMOS VAJAR CON VIEN. 3 DE ENERO DE 1990.

Virgin of Guadalupe, we dedicate this in your honor for having allowed us to come down safely from Ixtaccihuatl. When my brother Paco fell into a crack in the volcano I sensed death was near, and entrusting ourselves to you, we were able to get down safely. January 3, 1990.

ALCOHOL

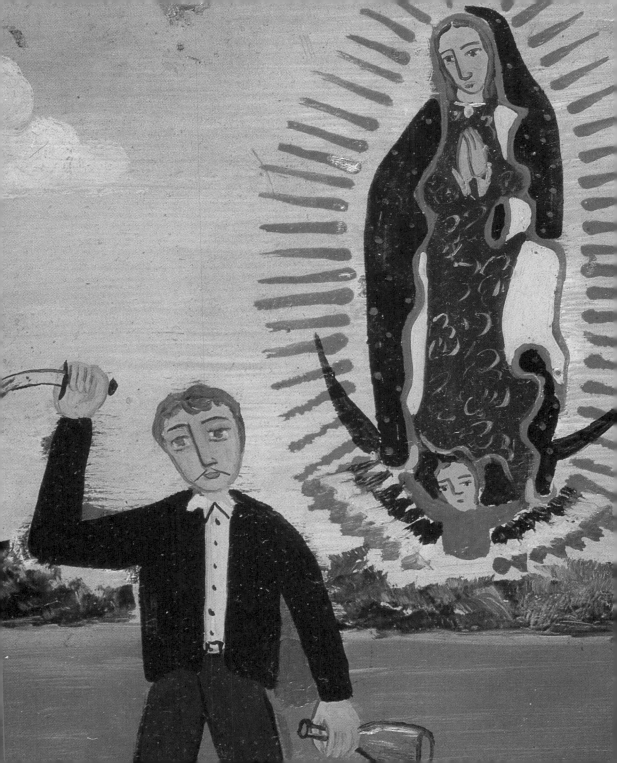

I almost lost my life over a married woman. As I was leaving the cantina, I was shot by the wronged man, who had already passed sentence on me. In this dire situation I prayed to the Most Holy Virgin of Guadalupe, saying that if I pulled through I would bring her this retablo, and here I am to keep my promise, because I am a man of my word. Felipe R——. This took place in the year 1930.

[On building:] Risks of Love Cantina

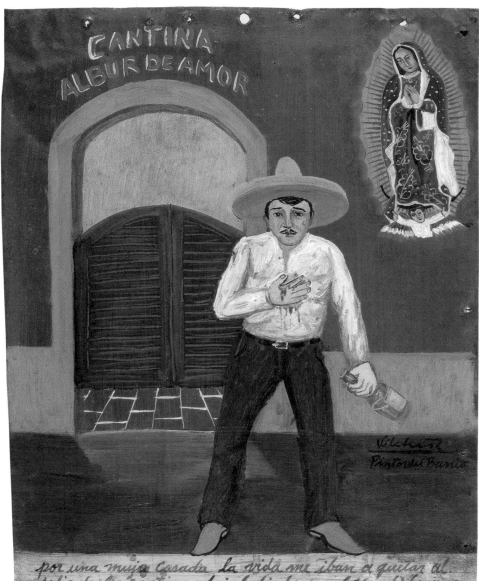

CANTINA
ALBUR DE AMOR

por una mujer casada la vida me iban a quitar al
salir de la cantina fui baliado por el ofendido que
ya me la abia sentenciado viendome en tal situasion
invoque a Maria Sma. de Guadalupe que si salia
de esta le traia este y aqui estoy pa cumplir porque
tengo palabra Felipe. Gto. aconteció el año 1930

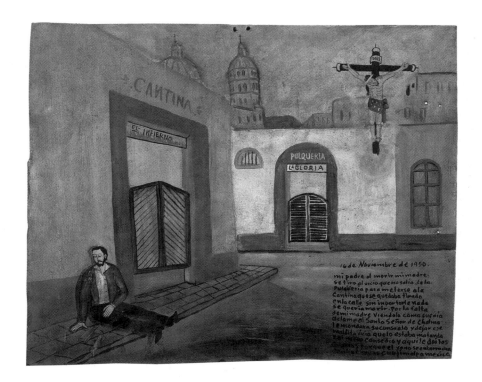

November 16, 1950

When my mother died, my father threw himself into vice and wouldn't leave the *pulquería**
unless it was to go to the cantina. He'd be lying in the street and didn't even care. He wanted to
die because my mother was gone. Seeing him in such pain, I appealed to Sacred Jesus of
Chalma to send him comfort and have him leave behind that cursed vice that was killing him.
He granted me this, and I here give thanks, because he doesn't get drunk anymore. Cecilia
C——. Cuajimalpa, Mexico.

[On building at left:] Hell Cantina

[On building at center:] Glory Pulquería

*Bar serving *pulque*, a liquor made from the maguey cactus

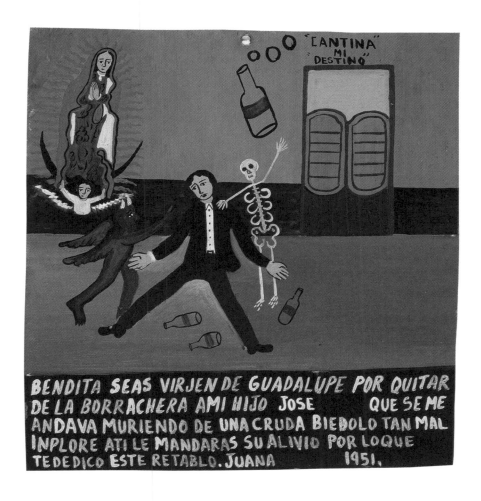

BENDITA SEAS VIRJEN DE GUADALUPE POR QUITAR
DE LA BORRACHERA AMI HIJO JOSE QUE SE ME
ANDAVA MURIENDO DE UNA CRUDA BIEDOLO TAN MAL
INPLORE ATI LE MANDARAS SU ALIVIO POR LO QUE
TE DEDICO ESTE RETABLO. JUANA 1951.

Blessed art thou, Virgin of Guadalupe, for rescuing from drunkenness my son José C——
who was dying from a terrible hangover. Seeing him so badly off, I begged you to cure him,
and for your grace I dedicate to you this retablo. Juana C——. 1951.

[On building:] My Fate Cantina

I give thanks to the Sweet Virgin for saving the life of my son Felipe, who while leaving Mass was shot by a friend who got drunk and shot him because people said he had been with his wife. Señora María R——. 1930. Barrio de la Soledad.

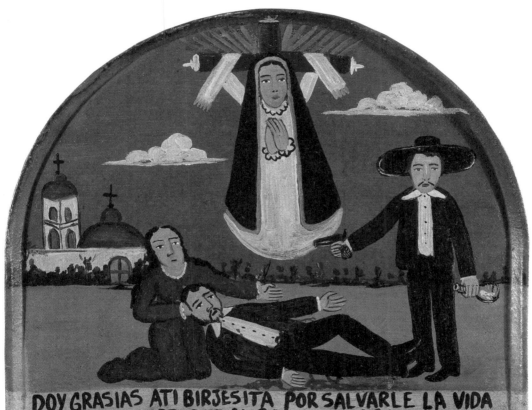

DOY GRASIAS ATI BIRJESITA POR SALVARLE LA VIDA
AMI HIJO FELIPE QUE AL SALIR DE MISA FUE BALIADO
POR UN AMIGO QUE AL VENIR BORRACHO LO BALIO
PORQUE LEDIJIERON QUE ANDABA COSUMUJER. SRA.—
MARIA 1930. VARRIO DE LA SOLEDAD

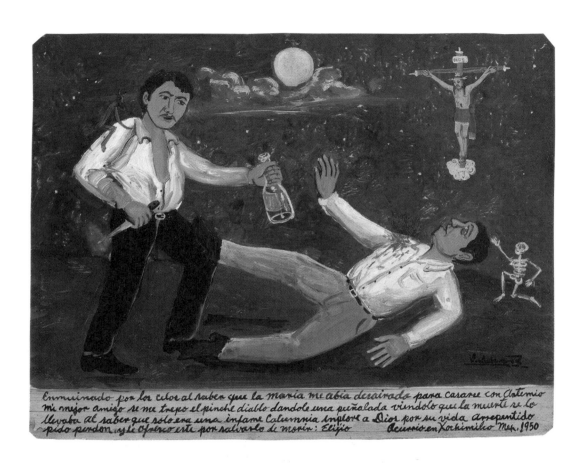

Enmurinado por los celos al saber que la María me abia desairado para casarse con Artemio mi mejor amigo se me trepo el pinche diablo dandole una puñalada viendolo que la muerte se lo llevaba Al saber que sólo era una infame Calumnia imploré a Dios por su vida arrepentido pido perdon, y le Ofrezco este por salvarlo de morir: Elijio Acurrio en Xochimilco Mex. 1950

In a jealous rage because María had thrown me over to marry Artemio, my best friend, the goddamn devil climbed up my back and I stabbed him. As death was carrying him off I learned that it was all just a horrible rumor. I begged God to spare his life, and in repentance asked forgiveness, and I offer Him this for saving him from dying. Elijio C——. This took place in Xochimilco, Mexico. 1950.

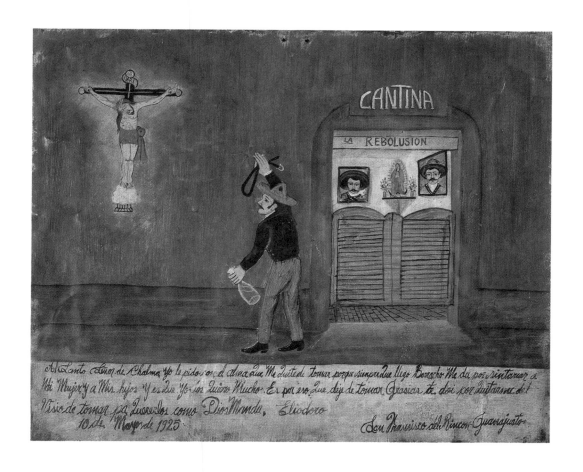

I begged from my soul that the Sacred Lord of Chalma would deliver me from drink. Because every time I come home drunk, I get the urge to take my belt and beat my wife and children, and really I love them very much. That is why I stopped drinking. I give you thanks for delivering me from the evil of drink so I may love them as God wills. Eliodoro B——R——. May 10, 1925. San Francisco del Rincón, Guanajuato.

[On building:] Revolution Cantina

My thanks to the Archangel of Justice because Guadalajara won El Clásico* over the United States, those fucking foreigners. My father-in-law kicked me out of his bar because I won the bet we made and now he has to shave his head bald. But I'm here to party because I'm a Chiva** through and through. Mexico D.F.

[On building:] We Did It! Cantina

[On sign inside building:]"No Chivas Allowed"

* Soccer championship

** The Guadalajara soccer team

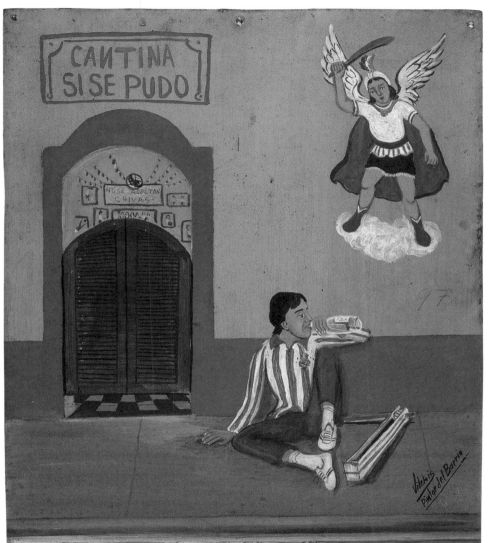

GRACIAS AL ARCANGEL JUSTICIERO PORQUE EL GUADALAJARA LE GANO
EL CLASICO AL AMERICA CON TODO Y SUS PINCHES EXTRANGEROS MISUEGRO
ME CORRIO DE SU CANTINA PORQUE LE GANE LA APUESTA Y SE VA PELAR PELON.
PERO AQUI ME QUEDO AFESTEJAR PORQUE SOY CHIVA DECORAZON. MEXICO DF.

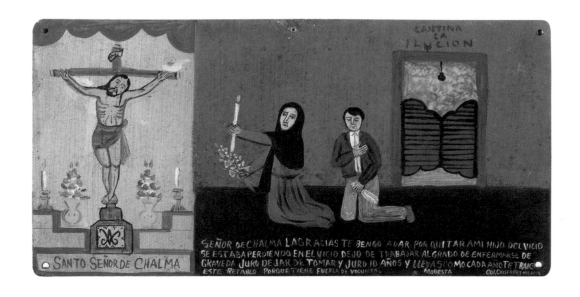

Lord Jesus of Chalma, I come to give you thanks for saving my son from vice. He was lost to vice, he stopped working, it got so bad that he fell seriously ill. He swore to stop drinking, he swore it for 10 years, and 5 have gone by, and I am bringing you this retablo, as I do every year, because he has willpower. Modesta G——. Colonia Cristo Rey, Mexico.

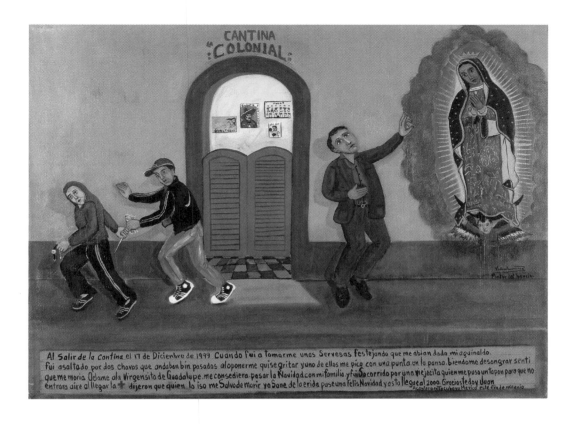

Al Salir de la Cantina el 17 de Diciembre de 1999 Cuando Fui a Tomarme unos Servesas Festejondo que me abian dado mi aguinaldo. Fui asaltado por dos chavos que andaban bin pasados al oponerme quise gritar y uno de ellos me pico con una punta en la pansa. biendome desongrar senti que me moria. Odame ala Virgensita de Guadalupe. me consediera. pesar la Navidad con mi familia y fui Socorrido por una viejecita quien me puso un Tapon para que no entrara aire al llegar la ✚ dijeron que quien lo iso me Salvo de morir yo Sane de lo erida puse una Felis Navidad y asta llegue al 2000. Gracias te doy Juan "Aconteserita cubaya Mexico este fin de milenio.

As I was leaving the cantina on December 17, 1999, when I had gone to drink a few beers because they gave me a bonus, two guys who were high on drugs attacked me. I tried to yell to stop them, and one of them stabbed me in the belly with a knife. Losing so much blood, I could feel I was dying. I appealed to the Sweet Virgin of Guadalupe to let me live to spend Christmas with my family, and I was rescued by an old lady who covered up my wound so air wouldn't get in. When the Red Cross came, they said whoever had done that had saved my life. The wound healed and I had a merry Christmas and even made it to 2000. I give you thanks. Juan C—— P. This took place in Tacubaya, Mexico, at the end of the millennium.

1934. I give you thanks, Virgin of Guadalupe, for shielding me from death when I was stabbed by my good friend, who was in a rage because he heard a rumor that I was flirting with his wife, which was not true. José P——.

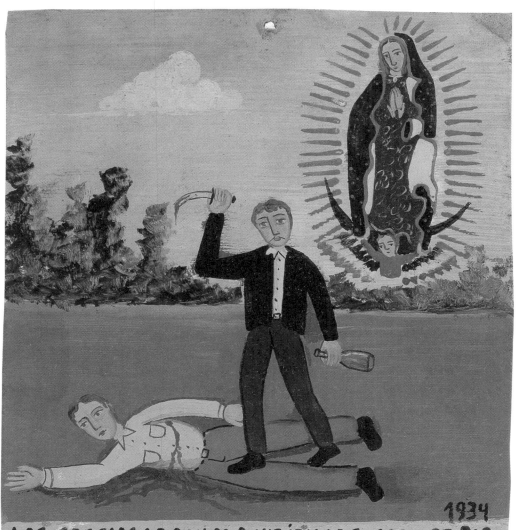

LAS GRASIAS LE DOY A LA VIRJEN DE GUADALUPE POR
GUARDARME DE LA MUERTE CUANDO FUI APUÑALADO
POR MI COMPADRE QUE VENIA VIEN EMUINIADO POR
UN CHISME QUE LE AVIAN DICHO QUE ANDABA —
ENAMORANDO A SU MUJER SIN SER SIERTO. JOSE P.

DRIVING

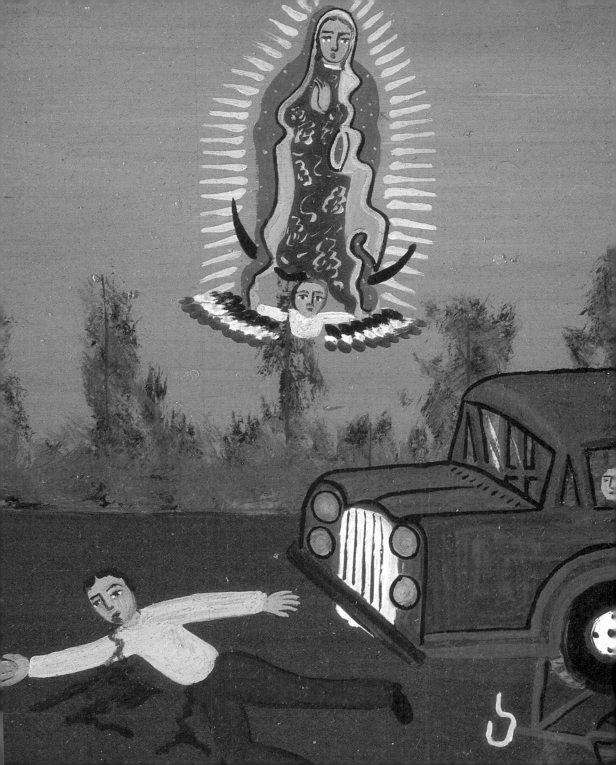

Blessed art thou, Sweet Virgin of Guadalupe, for delivering me from death the time I foolishly drove really drunk. Antonio B——. Mexico D.F. Sept. 16, 1975.

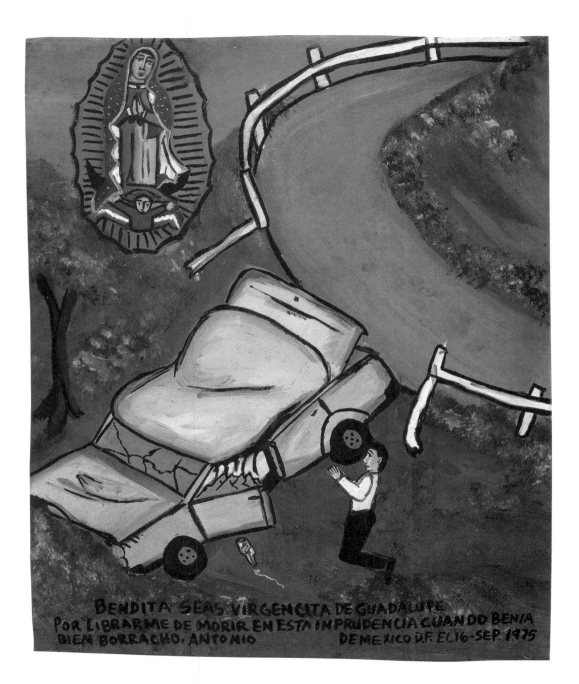

BENDITA SEAS VIRGENCITA DE GUADALUPE
POR LIBRARME DE MORIR EN ESTA INPRUDENCIA CUANDO BENIA
BIEN BORRACHO. ANTONIO DE MEXICO D.F. EL 16-SEP. 1975

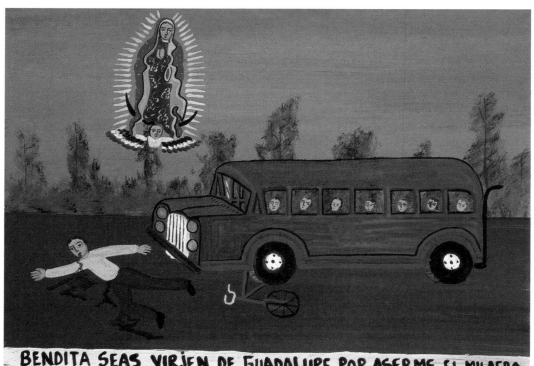

BENDITA SEAS VIRJEN DE GUADALUPE POR ASERME EL MILAGRO
DE SACAR CON VIEN DE UNA OPERASION DE LA COLUCNA AMI HIJO
FIDEL QUE FUE ABENTADO EN SU VISICLETA POR UN CAMION Y YA
PUEDE CAMINAR POR LOQUE TE DOY INFINITAS GRASIAS
SEÑORA, LUPE COYOACAN, MEXICO 1989

Blessed art thou, Virgin of Guadalupe, for granting me the miracle of getting my son Fidel
safely through an operation on his spine after he got hit by a truck while on his bicycle, and
now he can walk. For this I give you infinite thanks, Our Lady. Lupe S——. Coyoacán, Mexico.
1989.

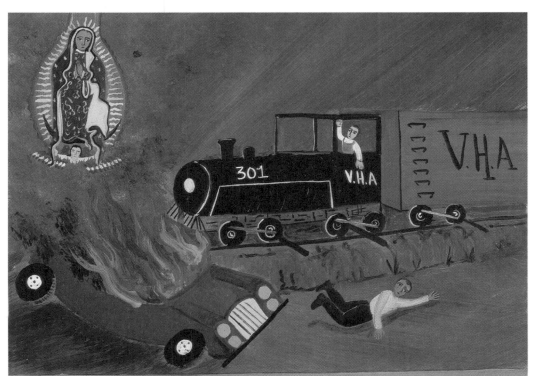

BENDITA SEAS MADRE MIA DE GUADALUPE POR ASERME EL MILAGRO DE SEGUIR
CON VIDA CUANDO QUISE GANAR EL PASO AL TREN Y AL VERME EN FATAL DESGRASIA
ACLAME ATI Y PUDE SALIR DEL COCHE CON VIEN POR LOQUE TE TRAIGO ESTE
ASTA TU ALTAR. ROMAN 10-DIC-1990

Blessed art thou, Our Mother of Guadalupe, for the miracle that I am still alive after I tried
to beat the train, and in this dire mishap I appealed to you and managed to get out of the
car to safety. For this I bring this retablo to your altar. Román C——. Dec. 10, 1990.

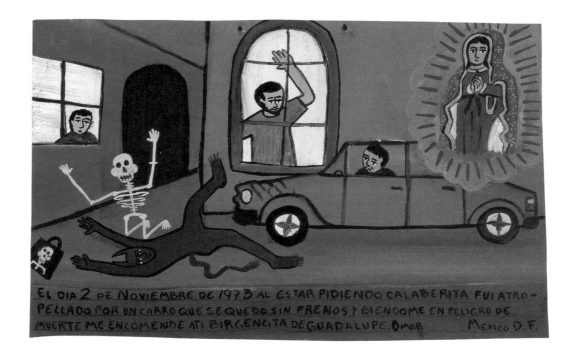

On November 2, 1973, as I was going around for *calaverita**, I was hit by a car that had no brakes. In danger of death, I entrusted myself to you, Sweet Virgin of Guadalupe. Omar D——. Mexico D.F.

*On the Day of the Dead (November 2), Mexican children make the rounds asking people to put money in their bags, marked with the image of a skull (*calavera*).

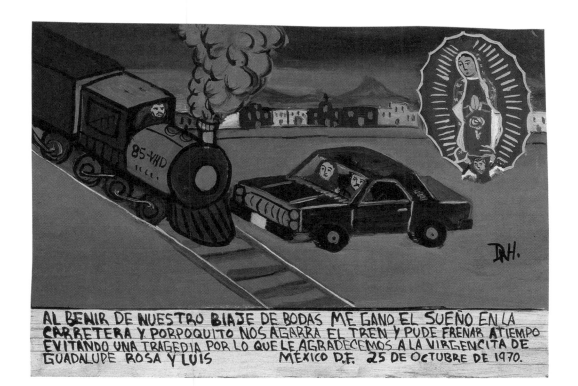

AL BENIR DE NUESTRO BIAJE DE BODAS ME GANO EL SUEÑO EN LA CARRETERA Y PORPOQUITO NOS AGARRA EL TREN Y PUDE FRENAR A TIEMPO EVITANDO UNA TRAGEDIA POR LO QUE LE AGRADECEMOS A LA VIRGENCITA DE GUADALUPE ROSA Y LUIS MÉXICO D.F. 25 DE OCTUBRE DE 1970.

Coming back from our honeymoon, I fell asleep on the road and we were almost run over by a train, and I was able to hit the brakes in time and avoid a tragedy. For this we give thanks to the Sweet Virgin of Guadalupe. Rosa and Luis C——. Mexico D.F. October 25, 1970.

I give thanks to San Judás Tadeo for keeping me from getting into a terrible accident on the way back from Pachuca with a full load of passengers. I was about to crash into another bus because I was drunk. In this difficult situation, I appealed to you for my safety and you granted it. You heeded my pleas, Señor, for which I vowed to bring you this. I have vowed to stop drinking as proof of my faith and gratitude. Porfirio G——. Azcapozalco, Mexico. December 31.

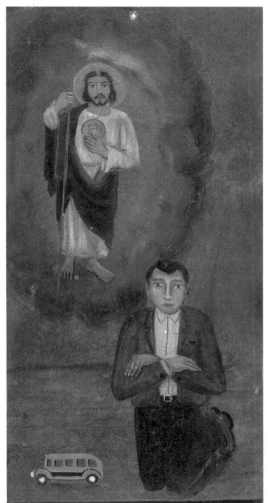

agradesco a San Juditas Tadeo. Por librarme de Cometer
Terrible acidente a Regreso de Pachuca Trallendo pasaje
lleno iba a chocar con otro autobus por benir borracho
albermeen dificil Situasión aclame me dieras lisensia de
llegar Con bien y asi ocurrio escuchaste mis ruegos Sr.
Porloque prometi traerteeste presente Prometidejardetomar
Como Muestra de Fe y Agradecimiento. Porfirio
AZCAPOSALCO Mexico 31 DICIENBRE Vita.

RELIGION

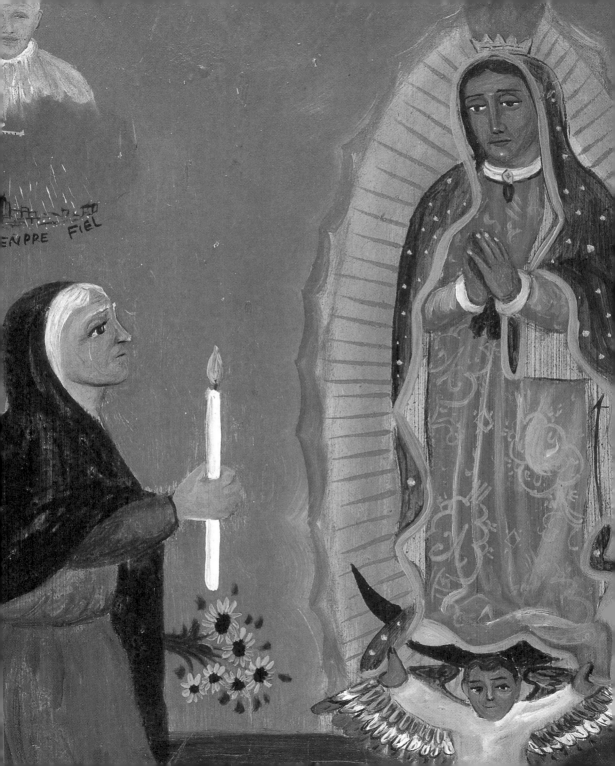

SIEMPRE FIEL

Lord Jesus of Chalma, I promised you this retablo if you would allow us to get to your altar on foot, and we did. We arrived safely and hope we will see you next year, if you permit us. Moco* and El Huevo.** Holy Week, 2000.

* Booger

** The Egg

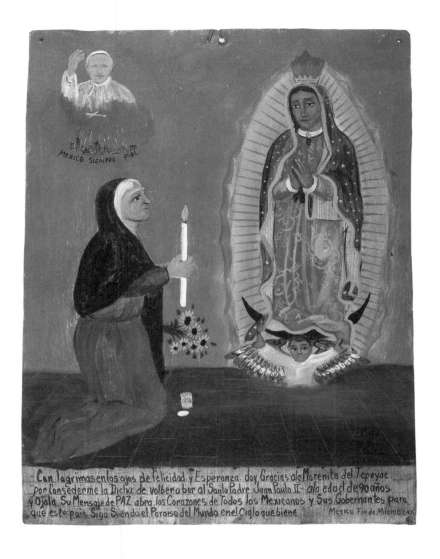

Con lagrimas en los ojos de felicidad. y Esperanza. doy Gracias ala Morenita del Tepeyac.
por Consederme la Dicha de volber a ber al Santo Padre Juan Paulo II ala edad de 90 años
y Ojala Su Mensaje de PAZ abra los Corazones de Todos los Mexicanos y Sus Gobernantes para
que este pais Siga Siendo el Paraiso del Mundo enel Ciglo que biene Mexico Fin de Milenio c-xx

With tears of joy and hope in my eyes, I give thanks to the Brown-skinned Lady of Tepeyac for granting me the good fortune of seeing His Holiness Pope John Paul II again, at the age of 90, and let us hope that his message of peace will open the hearts of all Mexicans and their leaders, so this country may continue to be the paradise of this world in the coming century. Mexico. End of the millennium. 20th century.

RURAL LIFE

To the Lord God and the Most Holy Mary of Guadalupe I offer this retablo for giving me back my fields that were given to me by my deceased parents, may they rest in peace. There was a mortgage on them for no reason at all. I prayed to you so hard, and here I am working them again, the way they wanted. I ask your blessing, because I have been left all alone. Serafín G——. Village of Cuajimalpa, Mexico. May 3, 1975.

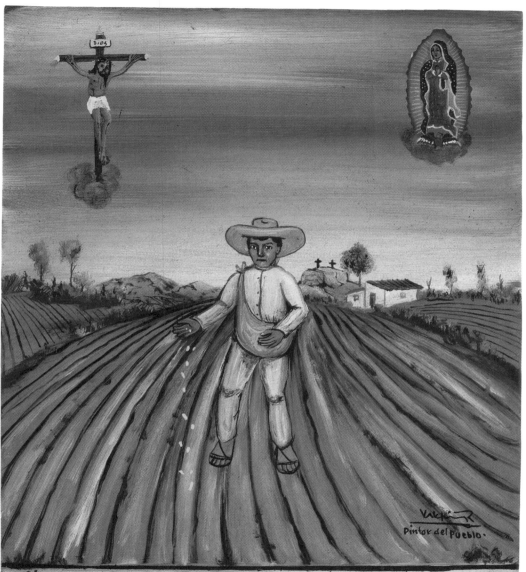

Vilche
Pintor del Pueblo.

a Dios Nuestro Señor y a Maria Sma. de Guadalupe le Ofresco este Retablito porque
ya me derolvieron mis tierras que me dejaron de herencia mis finados padres que en
paz descancen me las abian ipotecado sin rason alguna tanto te lo se lo pedi y aqui estoi
trabajandolas como fue su voluntad. su vendición les pido porque me e quedado tan solo.
Serafin Pueblo de Cuajimalpa Mexico 3 maijo 1975.

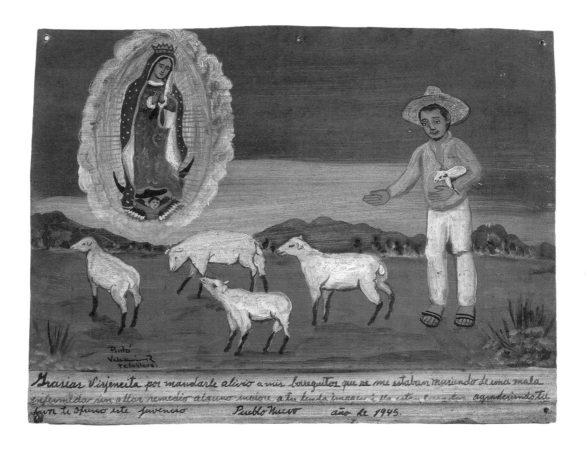

Thank you, Sweet Virgin, for curing my sheep, who were dying of a terrible disease. Finding no remedy, I prayed to your fair image, and now they are well. In thanks for your favor I offer you this. Juvencio R——. Pueblo Nuevo. Year 1945.

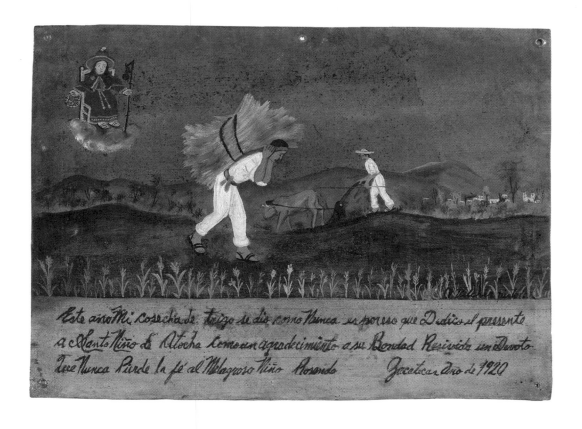

This year my wheat harvest was better than ever. That is why I dedicate this to the Holy Infant of Atocha in thanks for His goodness to a devoted servant who never loses faith in the Miraculous Infant. Rosendo C——. Zacatecas. Year 1920.

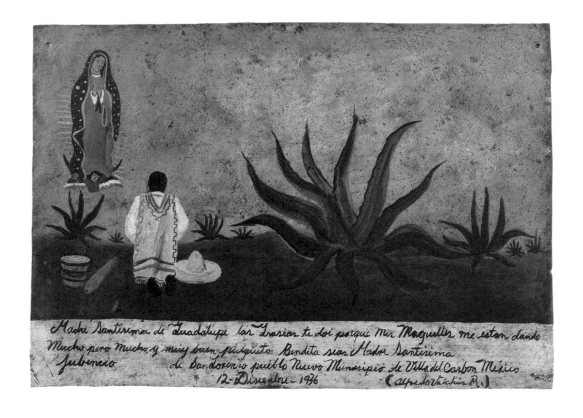

Most Holy Mother of Guadalupe, I bring you thanks because my magueys* are giving me lots and lots of really good *pulque*.** Blessed art thou, Most Holy Mother. Juvencio R—— of the village of San Lorenzo in the new township of Villa del Carbón, Mexico. December 12, 1936.

* A type of cactus

** Liquor made from maguey

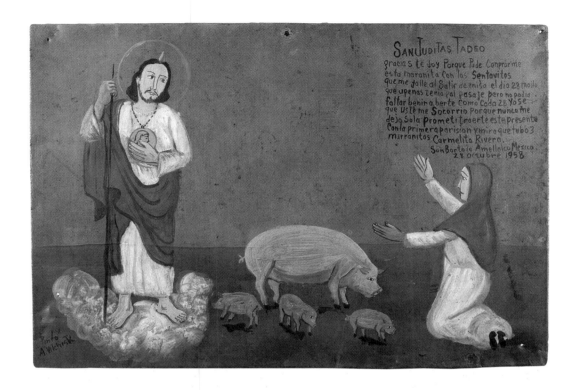

San Judás Tadeo, I give you thanks because I was able to buy this sow with the money I found on my way out of Mass on the 28th of May. I hardly had enough to pay my fare, but I could not fail to come and see you as I do every 28th. I know you came to my aid, because you have never left me alone. I promised to bring you this retablo when the first litter came. She had 3 piglets. Carmelita R——. San Bártolo Ameyalco, Mexico. October 28*, 1958.

*Feast day of San Judás Tadeo

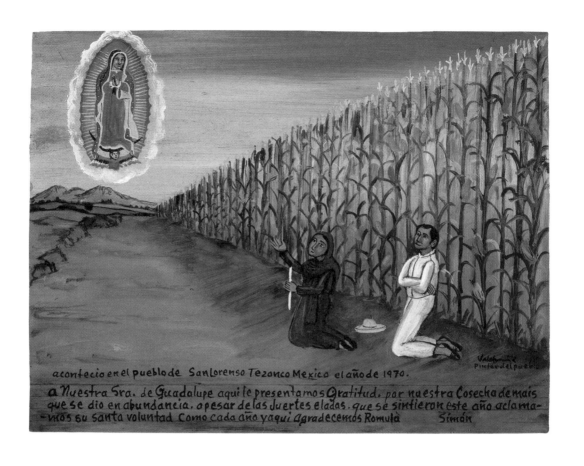

acontecio en el pueblo de San Lorenso Tezonco Mexico el año de 1970.

a Nuestra Sra. de Guadalupe aqui le presentamos Gratitud. por nuestra Cosecha de mais que se dio en abundancia. o pesar de las fuertes eladas. que se sintieron este año aclama-mos su santa voluntad Como cada año y aqui agradecemos Romula Simón

This took place in the village of San Lorenzo Tezonco, Mexico, in the year 1970.
We give thanks here to Our Lady of Guadalupe for our corn crop, which was plentiful despite the heavy frosts we had this year. We appealed to your holy will, as we do every year, and now we give thanks. Rómula P——, Simón E——.

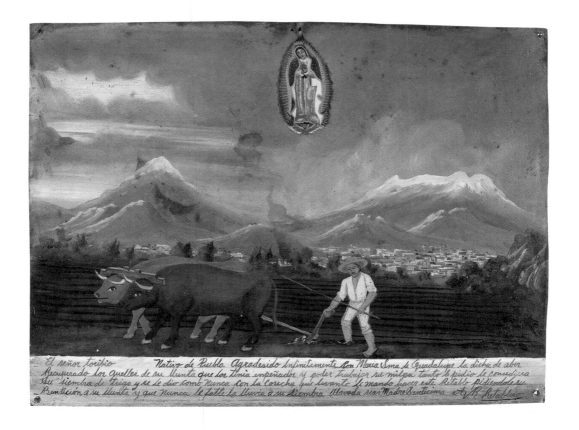

El señor toribio Nativo de Puebla Agradesido Infinitamente con Maria Sma de Guadalupe la dicha de aber Recuperado los quelles de su Yunta que los tinia empeñados y poder trabajar su milpa tanto le pidio le consediera su siembra de trigo y se le dio como nunca con la Cosecha que levante le mando hacer este Retablo pidiendole su Bendicion a su Yunta y que nunca le falte la lluvia a su siembra Alavada sea Madre Santicima A.M. Retablo

Señor Toribio V——, a native of Puebla, gives infinite thanks to the Most Holy María of Guadalupe for the good fortune of getting back his team of oxen, which he had pledged as bond, and being able to work his field. He prayed to you so hard to grant his sowing, and the yield was like never before with the wheat crop that came up I am having this retablo made to ask your blessing for my team, and that rain never be lacking at sowing time. Exalted art thou, Holy Mother.

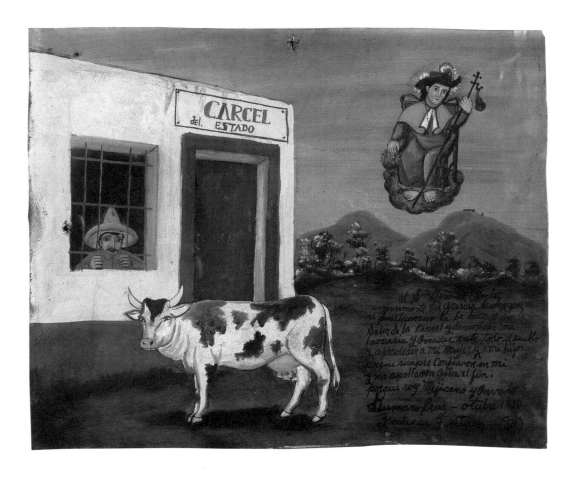

To the Holy Infant of Atocha, my immense gratitude, because at last the cow showed up and I could get out of jail to prove my innocence and honor before the whole town and thank my wife and my son, who believed in me always and supported me to the last. Because I am Mexican and honorable. Gumaro C——. October 1920. Zacatecas, Zacatecas.

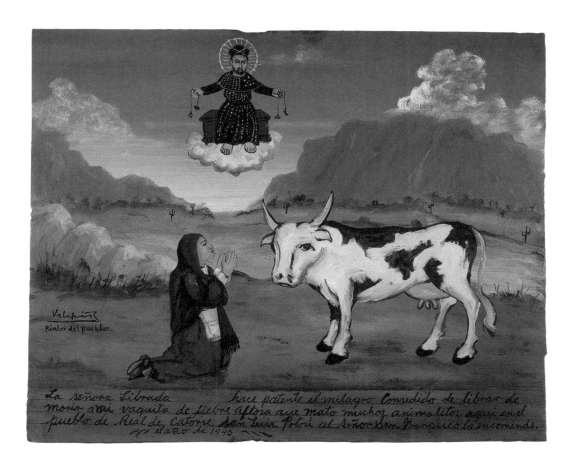

La señora Librada hace patente el milagro Conredido de librar de morir a mi vaquita de fiebre aftosa que mato muchos animalitos aqui en el pueblo de Real de Catorse San Luis Potosi al Señor San Francisco la encomende el año de 1945

Señora Librada U—— bears witness to the working of a miracle, that my cow was saved from dying of the hoof-and-mouth disease that was killing a lot of animals here in the village of Real de Catorce, San Luis Potosí. I entrusted her to the care of Señor San Francisco. The year of 1945.

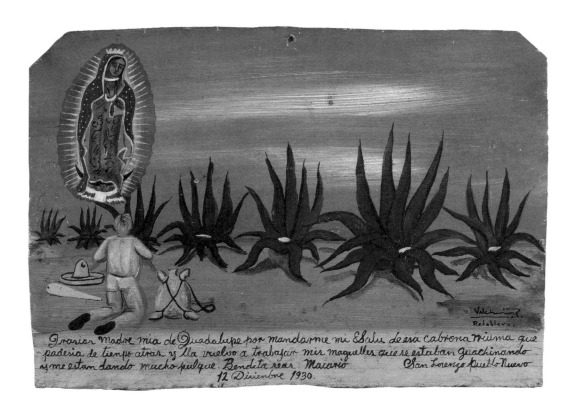

Thank you, Our Mother of Guadalupe, for giving back my health after that blasted rheumatism I was suffering for so long. Now I am working my magueys again, which had been getting waterlogged, and they are giving me a lot of *pulque*. Blessed art thou. Macario S——. San Lorenzo Pueblo Nuevo. December 12, 1930.

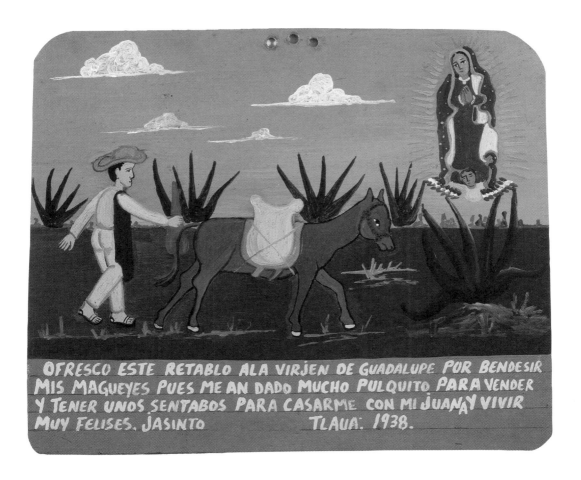

OFRESCO ESTE RETABLO ALA VIRJEN DE GUADALUPE POR BENDESIR MIS MAGUEYES PUES ME AN DADO MUCHO PULQUITO PARA VENDER Y TENER UNOS SENTABOS PARA CASARME CON MI JUANA Y VIVIR MUY FELISES. JASINTO TLAUA. 1938.

I offer this retablo to the Virgin of Guadalupe for blessing my magueys, because they gave a lot of *pulque* to sell, so I could get a little money to marry my Juana and live happily. Jasinto M——. Tlahua. 1938.

While playing with the pigs, a little boy, Casimiro, was bitten and could not move his fingers. I prayed so hard that you would heal him, and now he can move them. With this retablo I give thanks. Petra C——. Querétaro. 1970.

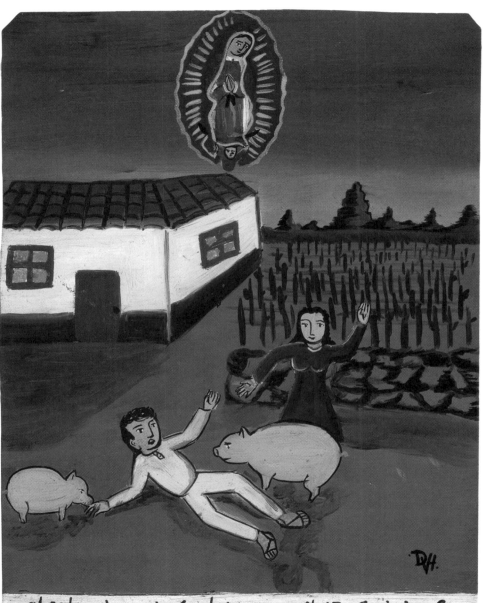

al estar Jugando Con los puercos el niño Casimiro fue
mordido sin poder mober los dedos tanto le pedi su alibio y lla.
puede moverlos yaqui Gracias ledoi Petra Queretaro 1970

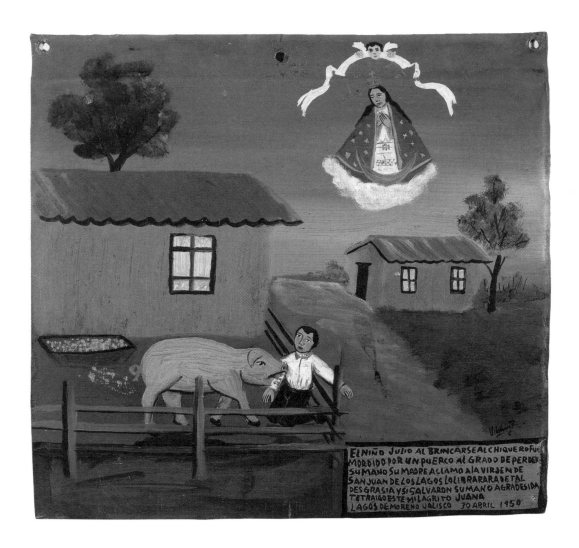

EL NIÑO JULIO AL BRINCARSE AL CHIQUERO FUE
MORDIDO POR UN PUERCO AL GRADO DE PERDER
SU MANO SU MADRE ACLAMO A LA VIRJEN DE
SAN JUAN DE LOS LAGOS LO LIBRARARA DE TAL
DESGRASIA Y SI SALVARON SU MANO AGRADESIDA
TE TRAIGO ESTE MILAGRITO JUANA
LAGOS DE MORENO JALISCO 30 ABRIL 1950

A little boy, Julio, jumped into the pigsty and was bitten by a pig severely enough to lose his hand, so his mother appealed to the Virgin of San Juan de los Lagos to deliver him from this misfortune, and they managed to save his hand. In gratitude I bring you this *milagro*. Juana O——. Lagos de Moreno, Jalisco. April 30, 1950.

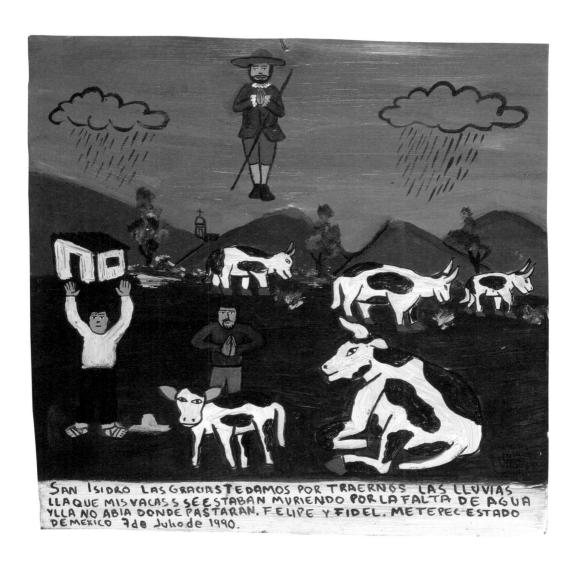

SAN ISIDRO LAS GRACIAS TE DAMOS POR TRAERNOS LAS LLUVIAS LLAQUE MIS VACAS SE ESTABAN MURIENDO POR LA FALTA DE AGUA YLLA NO ABIA DONDE PASTARAN. FELIPE Y FIDEL. METEPEC ESTADO DE MEXICO 7 de Julio de 1990.

San Isidro, we give you thanks for bringing the rains, because my cows were dying for lack of water and there was nowhere left for them to graze. Felipe and Fidel. Metepec, State of Mexico. July 7, 1990.

I give you thanks for healing my ribs when I was kicked by my horse. I prayed for your aid because I could not move and nothing could be done for me, and now I am completely well, for which I offer you this retablo in thanks for your grace. Román C——. Atlacomulco, Mexico. May 12, 1955.

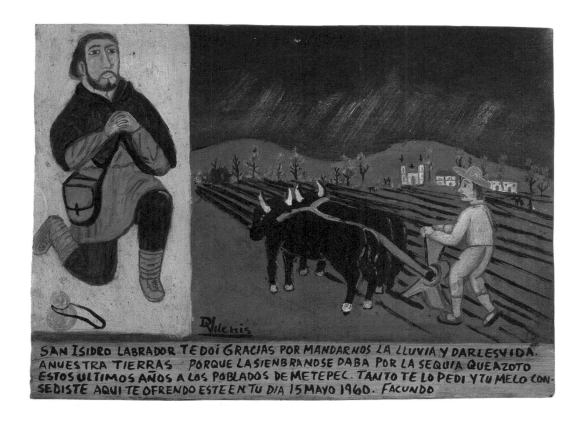

SAN ISIDRO LABRADOR TE DOI GRACIAS POR MANDARNOS LA LLUVIA Y DARLES VIDA. A NUESTRA TIERRAS PORQUE LA SIENBRA NOSE DABA POR LA SEQUIA QUE AZOTO ESTOS ULTIMOS AÑOS A LOS POBLADOS DE METEPEC. TANTO TE LO PEDI Y TU MELO CON-SEDISTE AQUI TE OFRENDO ESTE EN TU DIA 15 MAYO 1960. FACUNDO

San Isidro the Plowman, thank you for sending rain and giving life to our land, for the crop would not yield because of the drought that has hit the villages around Metepec for the last few years. I prayed so hard for your aid, and you granted it. I bring you this offering on your Saint's Day, May 15, 1960. Facundo M——.

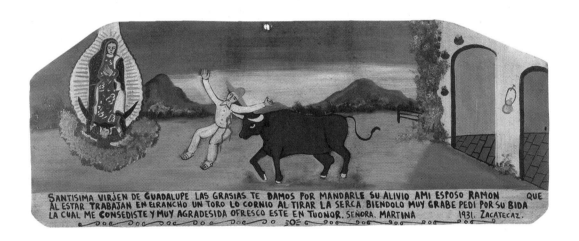

SANTISIMA VIRJEN DE GUADALUPE LAS GRASIAS TE DAMOS POR MANDARLE SU ALIVIO AMI ESPOSO RAMON QUE AL ESTAR TRABAJAN EN ELRANCHO UN TORO LO CORNIO AL TIRAR LA SERCA BIENDOLO MUY GRABE PEDI POR SU BIDA LA CUAL ME CONSEDISTE Y MUY AGRADESIDA OFRESCO ESTE EN TUONOR. SEÑORA. MARTINA 1931. ZACATECAZ.

Most Holy Virgin of Guadalupe, we thank you for healing my husband, Ramón D——, who while working on the farm was gored by a bull that jumped over the fence. Seeing him in grave condition, I prayed for his life, which you granted. In great gratitude I offer this in your honor. Señora Martina M——. 1931. Zacatecas.

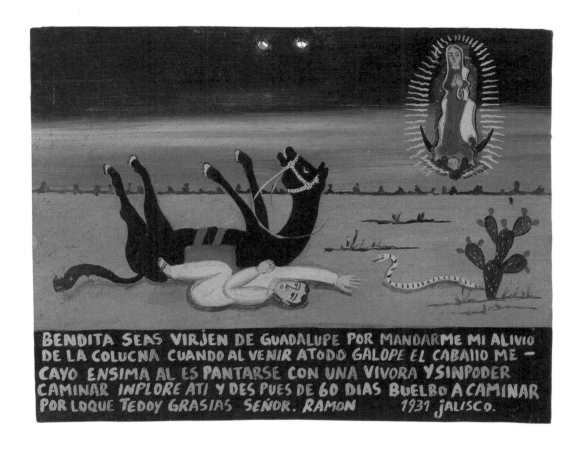

BENDITA SEAS VIRJEN DE GUADALUPE POR MANDARME MI ALIVIO
DE LA COLUCNA CUANDO AL VENIR ATODO GALOPE EL CABAllO ME —
CAYO ENSIMA AL ES PANTARSE CON UNA VIVORA YSINPODER
CAMINAR INPLORE ATI Y DES PUES DE 60 DIAS BUELBO A CAMINAR
POR LOQUE TEDOY GRASIAS SEÑOR. RAMON 1931 jALISCO.

Blessed art thou, Virgin of Guadalupe, for healing my spine when my horse, at full gallop, fell on top of me when it was frightened by a snake. I could not walk, and I prayed to you, and now, after 60 days, I am walking again, for which I give you thanks. Señor Ramón L——. Jalisco. 1931.

DROWNING

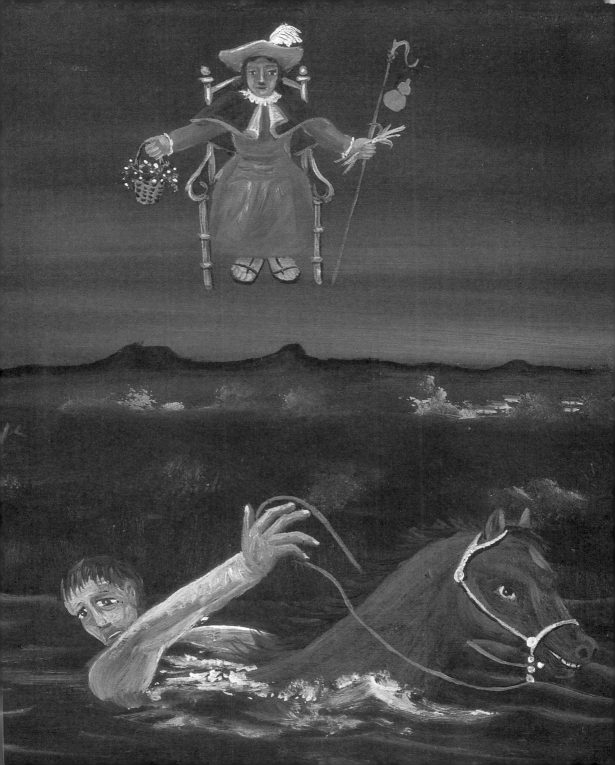

On the 6th day of January of 1957 the child Esteban C—— fell into a canal in Xochimilco. When his brother Juan saw that he was drowning, he dashed over to pull him out. Seeing them in such bad danger, I begged San Judás Tadeo to give my sons strength to get through this danger. You granted it, for which I promised to have this retablo made for granting the favor. Señora Juana R——. San Pedro Xochimilco, Mexico. Thank you, Señor, for taking pity on them.

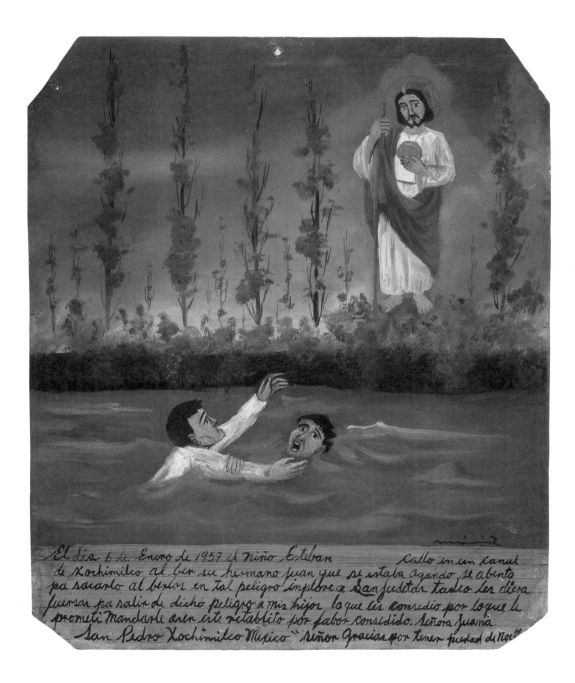

El dia 6 de Enero de 1957 el niño Esteban callo en un canal
de Xochimilco al ber su hermano Juan que se estaba agando se abento
pa sacarlo al bentos en tal peligro implore a San Judtar tadeo les diera
fuersas pa salir de dicho peligro a mis hijos lo que les consedio por loque le
prometi Mandarle aser este retablito por fabor consedido. Señora Juana
San Pedro Xochimilco Mexico "señor Gracias por tener piedad de Nou

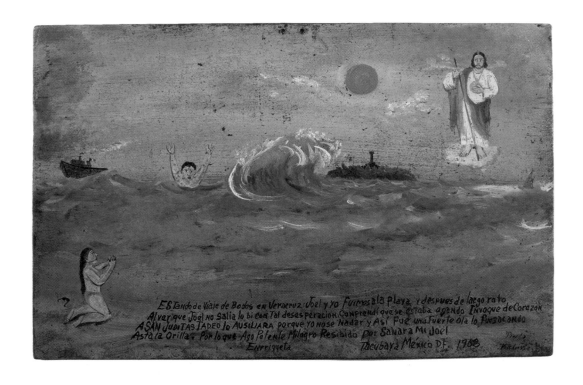

ESTando de Viaje de Bodas en Veracruz. Joel y yo Fuimosa la playa y despues de largo rato
Al var que Joel no salia lo bi con Tal deses peracion. Comprendi qve se estaba agando Invaque de Corazon
A SAN JUDITAS TADEO lo AUSILIARA porque yo no se Nadar y Así Fue una Fuerte ó la Puesacando
Asta la Orillas Por lo que Ago Patente Milagro Resibido Por Salvar a Mi Joel
Enrriqueta Tacubaya México D.F. 1968

On our honeymoon in Veracruz, Joel and I were at the beach, and after a long time, when
Joel didn't come out, I saw him in a desperate state. I realized he was drowning, and with
all my heart, implored San Judás Tadeo to help him, because I don't know how to swim.
And thus it happened. A strong wave swept him toward the shore, and for this I make
known the miracle performed to save my Joel. Enriqueta F——. Tacubaya, Mexico D.F. 1968.

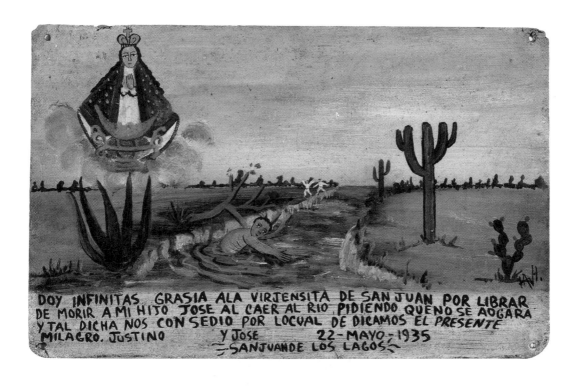

My infinite gratitude to the Virgin of San Juan for delivering my son from death when he fell into the river. He prayed that he would not drown, and we were granted this good fortune, for which we dedicate to you this *milagro*. Justino R—— and José R——. May 22, 1935. San Juan de los Lagos.

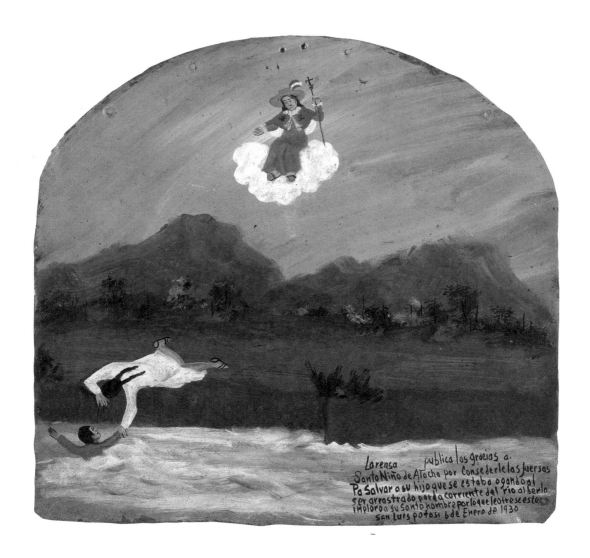

Lorensa publica las gracias a. Santo Niño de Atocha por Consederlelas fuersas Pa Salvar a su hijo que se estaba ogandoal ser arrastrado porla corriente del rio alberlo iMploroa su Santo hombre por loque leofreseeste san Luis potosi 6de Enero de 1930

Lorenza P—— makes known her thanks to the Holy Infant of Atocha for granting her the strength to save her son, who was drowning when he got swept away by the current of the river. When she saw this she prayed to His sacred name, and for this she offers Him this [retablo]. San Luis Potosí. January 6, 1930.

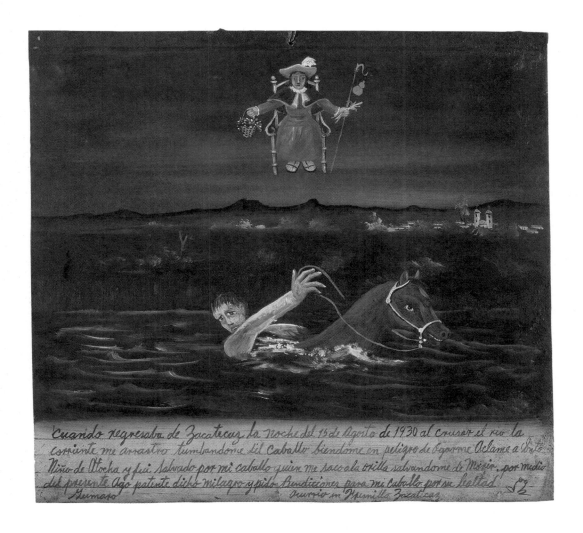

'Cuando regresaba de Zacatecas la noche del 15 de Agosto de 1930 al cruzar el rio la corriente me arrastro tumbandome del Caballo biendome en peligro de Ogarme Aclame a Srto Niño de Atocha y fui Salvado por mi caballo quien me saco a la orilla salvandome de Morir. por medio del presente Ago patente dicho milagro y pido Bendiciones para mi caballo por su lealtad. Gumaro ocurrio in Fresnillo Zacatecas

When I was returning to Zacatecas the night of August 15, 1930, as I crossed the river the current swept me away, spilling me off my horse. In danger of drowning, I appealed to the Holy Infant of Atocha and was saved by my horse, who pulled me out on shore, saving me from death. With this retablo I make known this miracle and ask blessings upon my horse for his loyalty. Gumaro S——. This took place in Fresnillo, Zacatecas.

DRUGS AND DEPRESSION

Señora Dionicia A—— gives thanks to the Virgin of Guadalupe that she came home in time to get her son down when he tried to hang himself because he was having problems at school. Mexico D.F. February 10, 1975.

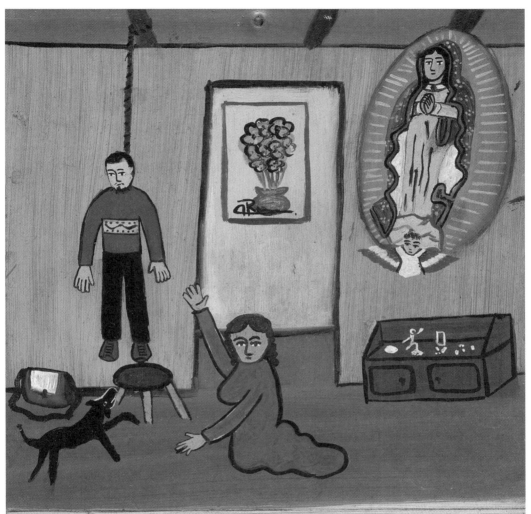

La Señora Dionicia le da gracias a la birgen de Guadalupe por permitirle llegar a tiempo a su casa y poder bajar a su hijo que se quiso ahorcar porque tenia problemas en su escuela. México D.F. a 10 de febrero de 1975

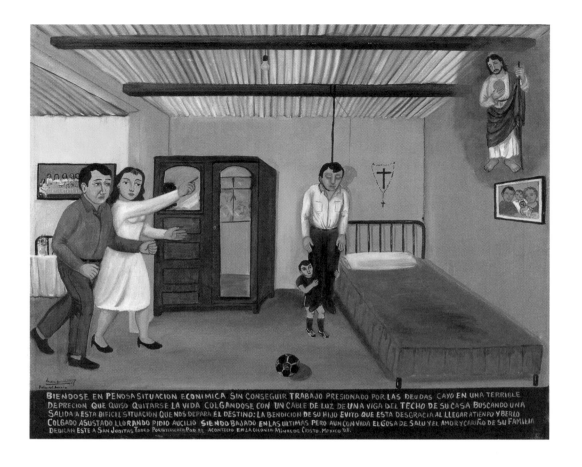

BIENDOSE EN PENOSA SITUACION ECONIMICA SIN CONSEGUIR TRABAJO PRESIONADO POR LAS DEUDAS CAYO EN UNA TERRIBLE DEPRECION QUE QUISO QUITARSE LA VIDA COLGANDOSE CON UN CABLE DE LUZ DE UNA VIGA DEL TECHO DE SU CASA BUSCANDO UNA SALIDA A ESTA DIFICIL SITUACION QUE NOS DEPARA EL DESTINO: LA BENDICION DE SU HIJO EVITO QUE ESTA DESGRACIA AL LLEGAR A TIENPO Y BERLO COLGADO ASUSTADO LLORANDO PIDIO AUCILIO SIENDO BAJADO EN LAS ULTIMAS PERO AUN CON VIDA EL GOSA DE SALU Y EL AMOR Y CARIÑO DE SU FAMILIA DEDICAN ESTE A SAN JUDITAS TADEO POR INTERSEDER POR EL ACONTECIO EN LA COLONIA MINAS DE CRISTO. MEXICO D.F.

In economic hardship, with no work, and under pressure from debt, he fell into a terrible depression and tried to kill himself. He hanged himself from the ceiling of his house with an electrical cord, seeking a way out of this hard situation fate had sent us: blessedly, his son saved him from this disaster when he went in just then and saw him hanging there, and, scared and crying, he called for help. Brought down at death's door but still alive, he now enjoys health and the love and affection of his family. We dedicate this to San Judás Tadeo for interceding for him. This took place in Colonia Minas de Cristo, Mexico D.F.

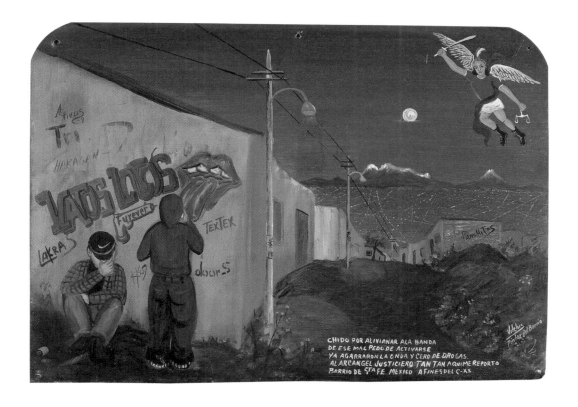

Right on for getting the gang out of that glue-sniffing shit. Now they got it right: zero drugs. To the Archangel of Justice: knock, knock, just letting you know. Barrio Santa Fe, Mexico. End of the 20th century.

I give thanks to the Virgin of Guadalupe that I found out my son was on an evil path and had fallen into the grip of vice by keeping bad company. I prayed so hard that you would help me tear him from the Devil's grasp, and now he has come back to the right path. Thank you for granting me this favor. María A——. Pensil, Mexico. April 1, 2000.

San Judás Tadeo, thank you for granting my freedom after I took a few centavos from the proceeds of the lottery tickets I had been selling, but you know that I took them to buy presents for my children for the feast day of the Reyes Magos,* I did it for them, because I never got a gift on the Reyes' day. And now, on January 6, my boss found out the truth and withdrew the charges. He told me I am innocent, because he was once a child and is a father too. 1968. Melchor G—— B——. This took place here in Mexico January 4, and I got out on January 6. Painted by Alfredo Vilchis Roque, retablo painter by vocation.

*At Christmastime in Mexico, the feast day of the Wise Men (Reyes Magos), January 6, is the day children receive gifts.

[On the wall of the cell, clockwise from top left:]
A poor man
won't be so poor
with the support
and smile of a friend.
—Chucho el Rato

The Tiger
of Santo Julio
was here

God never dies

Lord
Forgive them
They know
not
what
they do.

I realized the sad reality that although I gave him everything materially, I had no communication with my only son. I paid no attention to who his friends were until I caught him taking drugs with a friend from high school who had gotten him into drugs. In tears I begged the Virgin of Guadalupe to help me save him, and she granted me this, and now I make known my gratitude. Señora Angela del V——. San Pedro de los Pinos, Mexico.

I was a drug addict. I'd do anything for it, I didn't give a fuck. If I didn't have any I'd even steal to get some. I had lots of friends, and I'd get thrown in the slammer and get out again and didn't care what my parents said. They never gave up on me. I overdosed one time and saw death up close. I give thanks to Lord Jesus of Chalma that I stopped, and I ask forgiveness from my parents. I promise them from my heart, zero drugs.

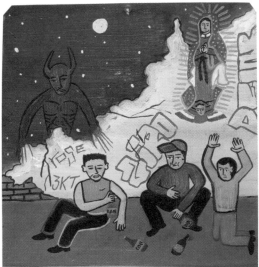

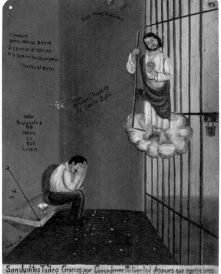
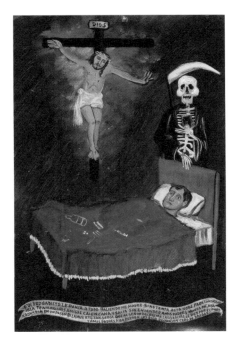

I fell into the vice of drinking and in despair I hanged myself with a pair of tights, trying to kill myself, and when I kicked away the bench I was standing on, the tights miraculously stretched until I could touch the ground. I saw a light that made me understand my error. I managed to untie my neck, giving thanks to the Sweet Virgin of Guadalupe for giving me another chance to live. I begged her to free me from this vice so I could get back my dignity and confidence, and the love and affection of my family, who suffered so badly to see me that way, and today, after a year of not drinking a single drop, I offer you this retablo in thanks. Edith Y—— A——. Col. Presidentes, Mexico D.F. August 28, 2002.

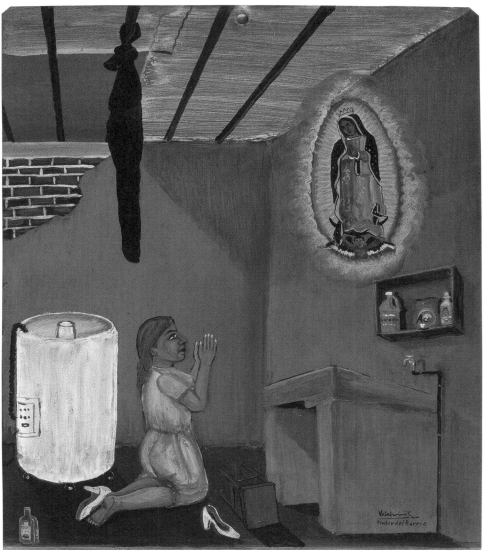

CALLENDO EN EL VICIO DE TOMAR ME BI EN LA DESESPERACION QUE ME COLGUE CON UN MAYON CON LA INTENCION
DE QUITARME LA VIDA Y AL ABENTAR EL BANCO QUE ME ABIA SUBIDO MILAGROSAMENTE EL MAYON SE ESTIRO TANTO QU PUDE
PISAR EL SUELO VI UNA LUZ QUE ME HISO CONPRENDER MI HERROR COMO PUDE ME DESAMARRE DEL CUELLO DANDO GRACIAS.
A LA VIRGENCITA DE GUADALUPE POR DARME OTRA OPORTUNIDAD DE VIVIR LE PEDI ME QUITARA DE ESTE VICIO Y RECUPERAR.
MI DIGNIDAD CONFIANSA, CARIÑO Y AMOR DE MI FAMILIA QUE TANTO HISE SUFRIR AL VERMEASI Y HOY AUN AÑO DE NO PROBAR.
UN SOLO TRAGO OFRECIENDOTE ESTE RETABLO TE DOY GRACIAS EDITH COL. PRECIDENTES MEXICO DF. 28-VIII-2008.

EXTRACTS FROM THE JOURNALS
OF ALFREDO VILCHIS ROQUE

I used to paint them on pieces of wrapping paper, the kind made into cones for selling sugar or a kilo of tortillas. I would unwrap them and keep them. Sometimes I'd color them using the little cobalt-blue cubes thrown out from Don Ferruz's pool hall, dissolved in sugar.

I remember I started working to help my mother with expenses. Don Raúl gave me a job selling newspapers on a corner in Bella Vista. Every day, I would take out my stand, a wooden triangle, and on a little cart I carried my newspapers and magazines. I was paid five pesos a day, from 7 A.M. to 12 noon, so I could go to the afternoon session of school.

Then I changed bosses, because sometimes he wouldn't let me go to school. My new boss, Don Pancho, was more scrupulous. There, on the curving street with the electrical wires in my barrio, Pino Suárez, when they opened the Observatorio metro station, I was the first to sell newspapers and magazines, in my inseparable wooden triangle and my little cart.

[Left page, caption:]
My stand was so pretty. They don't have those anymore.

What wonderful moments I spent doing my job and making drawings of Kalimán* or of myself or Supersabios,* my mom, with her black, black braids, bringing me breakfast because she didn't want things to go badly for me.

Afterward, I was a helper for a mason (Don Benito), who sometimes didn't even pay me, or a helper for the roofers Don Chino or Don Paulino Valencia or with their son-in-law Luis el Pichi** or Emilio.

What a shit job it is to mix mortar.
Carrying it up to whatever floor it was.
Carrying up bricks or tiles. Heating up lunch.

Not forgetting that I also did smaller errands. I'd go get gas. They'd give me a copper twenty-centavo piece. Or I'd go to bring five one-liter bottles of alcohol at a time for Don Fernando and Doña Maci, who sold spiked cinnamon drinks. They paid me with two *sopes*** or tostadas and a soft drink for helping keep the refrigerators filled with beer, or the tubs with sodas, and filling them with water and crushing the ice. Sometimes I even sold the cinnamon drinks, along with my step-father, Don Delfino Hernández, the famous captain. What times those were.

[Right page, captions, clockwise from top left:]
Bricks
5th floor
Bucket of mortar
Buckets of [. . .]
Sack of [. . .]
Barrel, Barrels
Tub
I'd fill them all
[. . .]
carry them up 5 floors
Buckets of water
Mixing

These were my jobs during those years. Very poor but very happy.

*Mexican comic-book characters

**Type of armadillo

***Corn biscuits with a topping

253

I sold so much that I was able to build myself a little house for my family, all the while anonymous. People would ask me not to sign them. I started buying books, magazines, newspapers, and images, and I would find out where a certain image was worshiped, who donated it, and why, where, and when. Materials. Patinas. I got books. Some were really pretty, but I decided not to copy from books. Out of respect.

I decided to paint what I see, feel, hear.

And make a record of whatever facts, events, or imaginings anyone asked me to—that speak of the history and customs of my beautiful, beloved Mexico.

Let it be known that when I formed this intention to make contemporary retablos and put events from the past and realities into visible form, I did not see or meet on my path anyone who was doing the same thing I was. Only in the museums or some basilica or church I visited—Chalmita—Los Remedios—San Juan de los Lagos—Silao, Gto.—Cristo Rey—I would return there as often as I could, not to copy them, but to be nourished by these precious objects.

In some antique shop there might be one.

The desire and need to make retablos, saints, and virgins was taking hold of me.

I fell into temptation—
to go and try my luck, at the whim of fate.

At the Sunday fair in La Lagunilla, like a wanderer I would set up in a corner and sell my retablos, along with other work I did—landscapes, still lifes, copies, homage to Frida Kahlo, whom I considered a master. I stopped doing miniatures and worked in different formats. I collected books and magazines of retablos, histories, and events, and looked at the murals of Diego Rivera, the master. I wanted to follow his example, making a portrait of the history of a people that had seen my birth and growth on these difficult byways of art.

In Guadalupe Posada I found another master of storytelling.

VENDIA TANTO QUE PUDE CONSTRUIR MICASITA Y PARA MI FAMILIA
PERMANECIENDO EN EL ANONIMATO LA GENTE ME PEDIA QUE NO
LOS FIRMARA. P
E DRESE A COMPRAR LIBROS REVISTAS PERIODICOS Y IMAGENES
-INVESTIGANDO DONDE SE VENERAN CIERTA IMAGEN QUIEN
LAS DONA Y PORQUE DONDE Y CUANDO MATERIALES.
PATINAS CONSEGUI LIBROS ABIA UNOS MUY BONITOS PERO YO
ME PROPUSE NO HACER COPIAS DELOS LIBROS. RESPETAR.

ME PROPUSE PINTAR LO QUE YO BEO O SIENTO. ESCUCHO.

Y ACER UNA CRONICA DE ECHOS. Y SUSESOS O IMAGINACIONES
Y PEDIDOS POR ALGUIEN - (QUE HABLEN DE LA HISTORIA Y COSTUMBRES
DE MI MEXICO LINDO Y QUERIDO

AGO SABER ESTO QUE CUANDO YO INICIE ESTE MOTIVO
DE HACER RETABLOS CONTEMPORANEOS O PLASMAR ECHOS
DEL PASADO Y REALIDADES.

NO BI NI ENCONTRE EN MI CAMINO A NINGUNA PERZONA.
QUE HISIERA LO MISMO QUE YO . SOLO EN LOS MUCEOS
O EN ALGUNA BACILICA. O . IGLECIA QUE YO RECORRI
CHALMITA - LOS REMEDIOS SAN JUAN DELOS LAGOS SILAO GTO
CRISTO REY - REGRESANDO A LA VILLA CADA QUE
PODIA - NO PARA COPIARLOS SINO PARA NUTRIRME DE ESAS
PRECIOCIDADES

EN ALGUNA TIENDA DE ANTIGUEDADES. ABIA UNO QUE OTRO .

EL DECEO O NECESIDAD DE HACER RETABLOS SANTOS Y VIRGENCITA
FUE APODERANDOSE DE MI

CAI EN LA TENTACION -
DE IR A PROBAR SUERTE POR CAPRICHO DEL DESTINO.

EN EL TIANGUIS DOMINICAL DE LA LAGUNILLA.
CONO NOMADA ME ACOMODADA EN ALGUN RINCONCITO.
Y AI BENDIA MIS RETABLITOS. JUNTO CON OBRA QUE YO HACIA
PAISAJES. BODEGONES. COPIAS HOMENAJE A FRIDA CALHO.
TOMANDOLA COMO MAESTRA:
DEJANDO ATRAS TAMAÑOS (MINIATURAS) TRABAJE VARIOS FORMATO
COLECCIONE LIBROS REVISTAS. DE RETABLOS HISTORIAS Y SUSESOS
MIRANDO LOS MURALES DEL MAESTRO DIEGO RIVERA:
QUISE SEGUIR SU EJEMPLO DE RETRATAR LA HISTORIA DE UN PUEBLO
QUE ME A BISTO NACER Y CRECER EN ESTOS DUROS CAMINOS DEL ARTE
S

EN GUADALUPE POSADA
ENCONTRE OTRO MAESTRO DE CONTAR UNA HISTORIA -